TOOLS & MATERIALS

A bit of reading before you hit the art supply store will give you a rough idea of what you'll need. At the store, please don't hesitate to ask the clerks for help. Most of them are also artists, and their experience can save you time and money.

PAINTS

There are many schools of thought that suggest using only limited color palettes and mixing all other colors, but, because horses are brown, gray, and black, I recommend a larger palette. You are going to be mixing colors a lot, and it will save time if you already have the colors you need. It is always better to have really good quality paint, the best you can afford. The less expensive student brands are fine for beginners.

In the 11 projects in this book, I use the following 16 colors in either watercolor or gouache, a more professional-grade paint that is also a water-based medium. I often use both types in my paintings, but you only need one.

Alizarin crimson	Cadmium red	Lamp black	Titanium white
Bright green	Cadmium yellow	Magenta	Ultramarine blue
Burnt sienna	Cerulean blue	Payne's gray	Viridian green
Burnt umber	Hooker's green	Raw umber	Yellow ochre

PAINTBRUSHES

While I recommend buying the best paint you can afford, sometimes you can save on paintbrushes. I rather like the art store's own brands that are synthetic and much less expensive than brushes with natural hair. I like synthetic brushes because they hold a point nicely, and, when they do wear out, they are still useful for applying masking fluid. They are also cheap to replace.

As with all artists, you will likely go through some trial and error figuring out what works and what doesn't work for you. I encourage artists to have an open mind and try brushes that might not even look like the right tools for the job. For instance, Chinese calligraphy brushes work really well for me for washes and flat areas of color, but they are absolutely not intended for this purpose.

Art supply stores always have a watercolor brush kit for beginners. I recommend these inexpensive kits as a way of trying a lot of different brushes. For the projects in this book, I use smaller round-tip brushes (sizes 0, 1, 2, and 3) for details, such as a rider's face. Larger round-tip brushes (sizes 6 and 7) are crucial for large washes of color. Again, experimenting with various shapes and brush sizes will help you determine what works best for you.

PALETTE

For my own purposes, I've combined two separate plastic palettes that just happen to fit well together. Any plastic palette with at least a few wells will work, but heavier plastic will last longer and survive daily wear and tear. You'll want enough smaller wells to hold the colors you are going to use the most. For paintings with large areas of color, your palette will also need mixing areas big enough to hold large amounts of paint. It's even possible to use a white dinner plate for mixing colors.

It's important to periodically wipe down your entire palette with paper towels or tissues to prevent your colors from getting muddy.

OTHER MATERIALS

You'll also need the following on hand:

- Plenty of light. My studio offers a lot of natural light. I have blinds that I can lower in the bright morning light, and I also use all sorts of florescent and incandescent lighting.

- Jars of water. I keep lids on mine so my cats don't drink the paint water.

- Pencils and erasers. I recommend using a 2B pencil because it is not too soft and is very easy to erase. I like Staedtler® Mars white vinyl erasers and kneaded erasers, which are invaluable because they remove masking fluid and pencil lines without leaving crumbs.

- Tissues, cotton swabs, and blotting paper. Before I put my brush to the surface I'm working on, I blot it first on a spare piece of paper, such as the backside of printer paper I've already used. This gets the paint flowing evenly so big gobs of water don't drip on the painting.

- Masking fluid. Using masking fluid helps protect the areas of your paintings that will use lighter color or show the white highlight of the paper. Apply masking fluid on top of your pencil sketch using an old brush. You'll need to wash the brush with soap and water to remove the rubbery residue. Once the painting is finished or nearly finished, you can remove the masking fluid and uncover the pristine bits of paper to work on below. Remove the masking fluid by carefully rubbing with a kneaded eraser, cotton swamp, or clean finger. If your eraser leaves crumbs, lightly sweep them off with a large brush.

▲ I always keep a sketchbook handy at my workspace to practice areas or work out problems in the thumbnail stage to ensure I understand the composition before moving to a larger work.

WATERCOLOR PAPER

Through many years of experimenting with different types of watercolor paper, canvas, and board, I now use Saunders Waterford® 140-lb hot-pressed paper for the vast majority of my work. I like the flat, clean surface of this paper, as hot-pressed does not have as much surface texture as cold-pressed paper.

PREPARING THE PAPER

I stretch my paper the old fashioned way. You'll need a piece of plywood, a light duty staple gun, and a pair of beveled pliers. You may also want to use a lamp (not fluorescent) or hair dryer to speed the drying process.

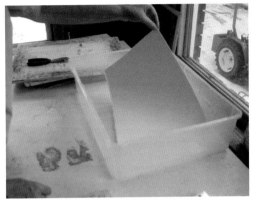

STEP 1 Begin by soaking the paper in tepid water in a large tray for about 10 minutes. To remove the paper, grab it by one corner and hold it up to let the excess water drain.

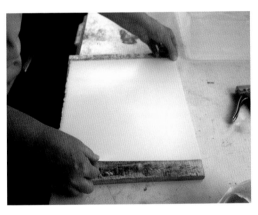

STEP 2 Place the paper on the plywood and blot with paper towels. Gently pull the paper diagonally across the long sides and place two staples near the center on the outer edge of each short side.

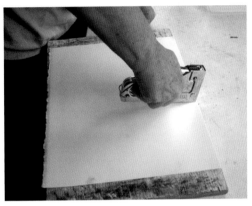

STEP 3 Grab one corner and pull diagonally. Hold the paper in place and put one staple on each side of the corner. Repeat for the other three corners.

STEP 4 Continue stapling along the outer edges until you've placed about eight staples per 14-inch side.

STEP 5 Gently blot more water out of the paper and place somewhere to dry for about 24 hours before painting. Once your finished painting is dry, gently remove the staples with your pliers. Trim off the stapled edges with a paper cutter.

USING YOUR PALETTE

These are the colors I use most often when painting equine subjects and their environments. Many horses and ponies share similar coloring with reddish brown coats and black manes and tails. This coloring is known as "bay," which I achieve using two main coat colors: cadmium yellow and burnt sienna. These swatches show you the shades you can achieve using these and various other colors from your palette. For each swatch, I used a 50-50 ratio of paint to water. The left side of the swatch shows you one layer of paint and the right shows how it darkens with a second layer added on top. To achieve more intensity, use a 75-25 ratio of paint to water. As you use more paint and less water, you are approaching the dry brush technique, i.e., the brush is almost devoid of water.

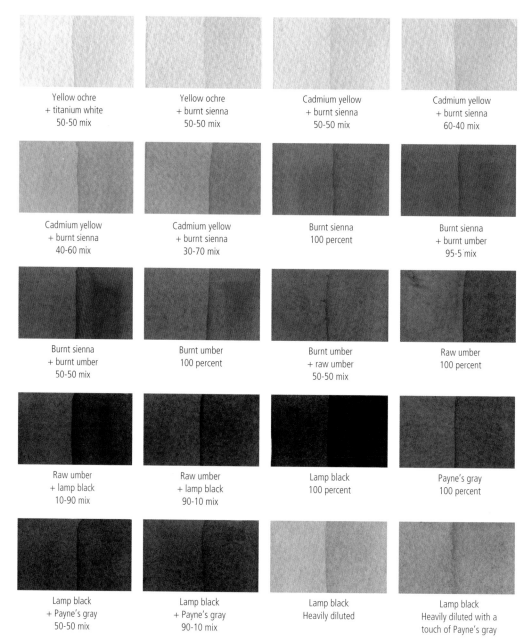

Yellow ochre
+ titanium white
50-50 mix

Yellow ochre
+ burnt sienna
50-50 mix

Cadmium yellow
+ burnt sienna
50-50 mix

Cadmium yellow
+ burnt sienna
60-40 mix

Cadmium yellow
+ burnt sienna
40-60 mix

Cadmium yellow
+ burnt sienna
30-70 mix

Burnt sienna
100 percent

Burnt sienna
+ burnt umber
95-5 mix

Burnt sienna
+ burnt umber
50-50 mix

Burnt umber
100 percent

Burnt umber
+ raw umber
50-50 mix

Raw umber
100 percent

Raw umber
+ lamp black
10-90 mix

Raw umber
+ lamp black
90-10 mix

Lamp black
100 percent

Payne's gray
100 percent

Lamp black
+ Payne's gray
50-50 mix

Lamp black
+ Payne's gray
90-10 mix

Lamp black
Heavily diluted

Lamp black
Heavily diluted with a
touch of Payne's gray

Cadmium yellow
+ cadmium red
50-50 mix

Cadmium yellow
+ cadmium red
30-70 mix

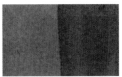

Alizarin crimson
+ raw umber
50-50 mix

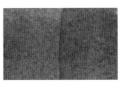

Alizarin crimson
+ burnt sienna
50-50 mix

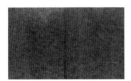

Alizarin crimson
+ burnt umber
75-25 mix

Ultramarine blue
100 percent

Ultramarine blue
+ cerulean blue
50-50 mix

Cerulean blue
100 percent

Cadmium yellow
+ bright green
50-50 mix

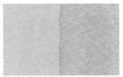

Bright green
100 percent

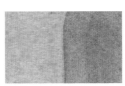

Bright green
+ yellow ochre
50-50 mix

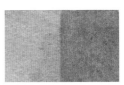

Yellow ochre
+ bright green
+ raw umber
40-40-10 mix

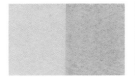

Cadmium yellow
+ Hooker's green
50-50 mix

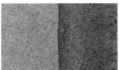

Hooker's green
100 percent

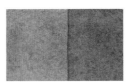

Hooker's green
+ ultramarine blue
50-50 mix

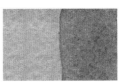

Hooker's green
+ cerulean blue
50-50 mix

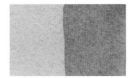

Cadmium yellow
+ viridian green
50-50 mix

Viridian green
100 percent

Viridian green
+ ultramarine blue
50-50 mix

Viridian green
+ cerulean blue
50-50 mix

Viridian green
+ burnt sienna
50-50 mix

Viridian green
+ raw umber
50-50 mix

Viridian green
+ Payne's gray
50-50 mix

Viridian green
+ lamp black
50-50 mix

UNDERSTANDING ANATOMY

Interestingly, riders from all levels and disciplines are learning more about the anatomy of a horse. This helps riders select saddles that fit both the horse and themselves and minimize pain and discomfort for the horse. Anatomy is also important for you to learn as an artist so your work is more realistic and your subjects are true to form.

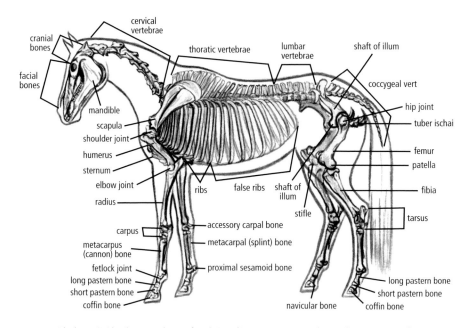

The bones inside a horse are the very foundation of its impressive size and strength. It is important for artists to understand exactly what the anatomy looks like under the shiny hide and sculpted muscles, both while the horse is standing still (above) and in motion (below). This helps you understand where the bony structures are, how the joints come together, and the basic underlying shapes. For instance, the elbow joint of the horse always causes a big shadow in paintings because the bone is really close to the surface.

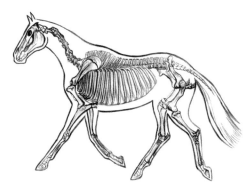

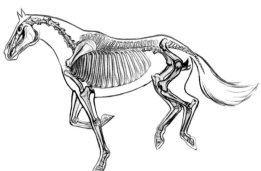

In a trot, a two-beat gait, the large hip joint flexes back to allow extension of the leg. The hock, with its incredible 11 bones, causes the range of motion. The legs are moving in diagonal pairs. The point of the stifle is always a bright highlight spot when painting horses because the bone is so close to the surface. There is usually a dark shadow right in front of it.

In a canter, a three-beat gait, the horse pushes off with its back bones and tendons. The backbones compress and expand with each leap forward as the head moves up and the neck stretches out. The bones that stick up behind the shoulder blade give some breeds high bony withers. Other breeds have less prominent withers, and the highest point of the hip also varies by breed.

This basic anatomy illustration shows the main muscle groups. As an artist, you should learn these groups and how they relate to the equine form so you can use them in your work. It is important to know what the muscle groups are, where they are located, and how they enable the horse's range of motion.

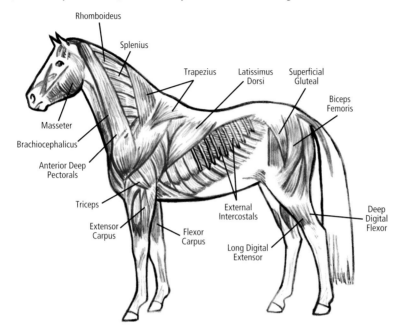

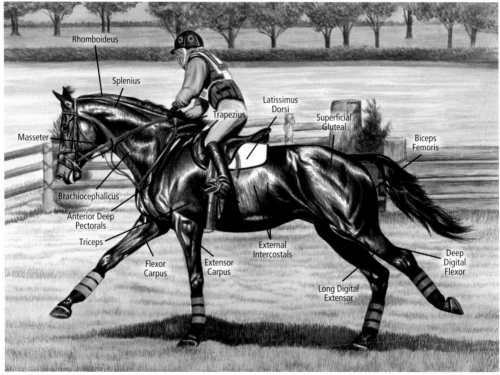

Here, in my painting called "Flat Out," you can see how the muscle groups from the illustration above are clearly visible under the thin, shiny hide of the horse. This is a very fit horse, and its defined muscles create shadows in various intensities. Below the knees, there isn't any muscle in the legs, just a series of tendons that allow the horse to reach great speeds.

VISUALIZING SHAPES

Now that you have been introduced to equine anatomy, bones, and muscles, it is time to learn how to see the underlying shapes that make up horses' heads and bodies and to depict the shapes on paper. You can practice first with these two exercises before moving on to the painting projects.

HEAD & NECK PENCIL SKETCH

Tip! Keep your wrist free and relaxed. Do not try to draw with just your hand.

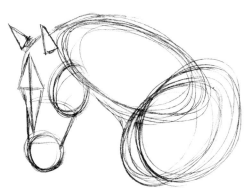

STEP 1 Start with the basic shapes to help you work up to an anatomically correct drawing. Facial features include an oval for the jowl, circle for the muzzle, triangles for the ears, and a diamond for the forehead. The neck is also an oval, and two overlapping circles shape the chest muscles. Simple lines finish the outline of the head and connect the basic shapes.

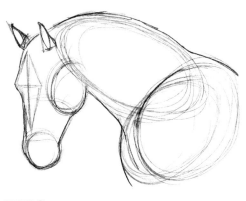

STEP 2 Lightly outline the outside edges of the shapes that will eventually define the head, neck, and chest. Round out the corners on the ears and outer edge of the diamond.

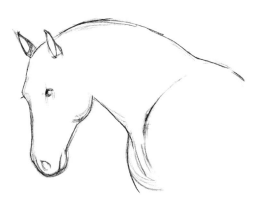

STEP 3 Begin to carefully erase the inner shapes and brush or blow away any eraser crumbs. Rough in the eye as an oval with pointed ends, and sketch in the nostril and mouth. You may also need to remove smudges from the outside of the drawing left by your hand.

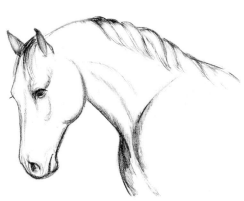

STEP 4 Continue to erase all unwanted lines inside the outline. Add detail as needed to help guide your painting. Darken the shoulder areas with shadows. Add heavier strokes to the mane. Lightly add strokes to suggest the cheekbone and the neck muscles. Continue to develop the eye, nostril, and mouth.

FULL BODY PENCIL SKETCH

Next, it's time to see how the same basic shapes used in the head and neck drawing are also used in a full body drawing.

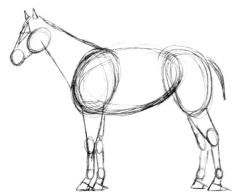

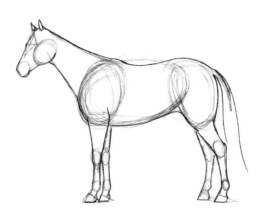

STEP 1 Start with the same shapes for the head as before. Add a triangle for the neck and loose circle for the chest and shoulder. A long oval forms the body but notice that it curves downward on the top line so it's almost a kidney shape. The circle forming the chest is repeated at the back to form the rump. The legs are downward facing triangles with their ends cut off. Draw the knees and fetlocks (lower ankles) with small ovals and circles. Then, add two parallel lines to form the pasterns below the ankles. A triangle creates each hoof.

STEP 2 Start outlining the outside edges of the shapes that will be a part of your final drawing and, eventually, your painting. Lengthen the tail and begin to round out corners and create more fluid lines.

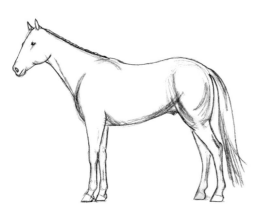

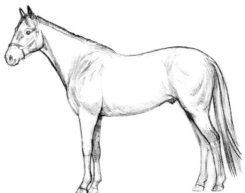

STEP 3 Continue rounding corners, such as between the neck and jowl. Join the nose to the face and erase lines as you go. Join the chest circle and the back to form the withers and back. Erase part of the back circle that creates the rump, and erase parts of the oval and circles in the knee and fetlock. Be careful not to make the knee and fetlock too round and knobby looking. Use gentle curves. Also erase the back corner of the triangles that form the hoofs. Finally, add in lines to suggest the tail and mane.

STEP 4 Add darker lines to continue defining and merging the different shapes into one cohesive form as you add depth and shading. Further develop the tail and mane with a mix of light and dark strokes. Then, outline the halter and darken the eye, leaving a small white highlight in the eye.

Once you have mastered seeing these basic shapes in the horse's appearance with accuracy and are able to draw them on paper, you are ready to begin applying color to your creations. Try for easily achievable goals, such as painting a horse's neck, mane, or back leg. When you are confident in capturing small areas of anatomy with relative ease, you can try a more complex project, such as the lessons that begin on page 22.

FOCUSING ON THE EYES

In my paintings, I always start with the eye. This is where you are really able to capture the likeness of a horse. Notice that horses have a horizontally placed and oval-shaped pupil, compared to the vertical slits of a cat's pupil or the perfectly round, centrally placed pupil in a human eye.

BILLY'S EYE

The eye you'll paint in this six-step lesson belongs to Billy, my Arab-Quarter horse who is very expressive. His eye is open but not too widely, so the shape forms an elongated oval that is flat in the middle and rounded on both ends.

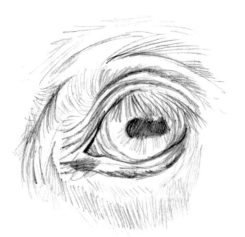

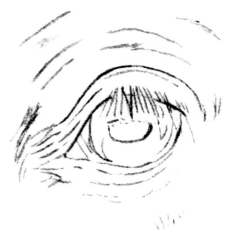

STEP 1 In the preliminary drawing, I use very rough pencil lines to represent the painting I plan to produce. This helps me understand the light and dark areas.

STEP 2 I set the pencil sketch aside to use as a reference and create a simplified outline using lamp black with lots of water. I outline the eyelid shape and put strokes in with a #3 brush for the creases, wrinkles, and the origin of the eyelashes. My strokes depict the direction the eyelashes grow and how long they are.

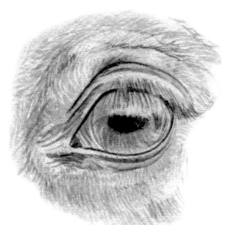

STEP 3 I add a reflection to the top of the eyeball with light washes of ultramarine blue. I outline the main lines again with heavily diluted lamp black and start to paint in light washes of burnt sienna. There is no hair on the eyelid, so I use lamp black in very light washes to suggest the skin. I use the same color for the inner eyelid in the corner of the eye.

Tip!

I always use a combination of the reference photo and the preliminary drawing when I begin to paint. If you choose to paint on top of your preliminary sketch, use diluted lamp black to outline the shapes. Wait for the paint to dry before erasing your lines and have a large brush on hand to sweep away eraser crumbs.

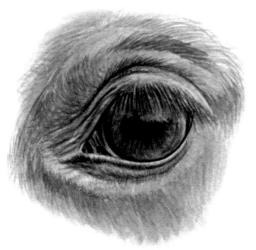

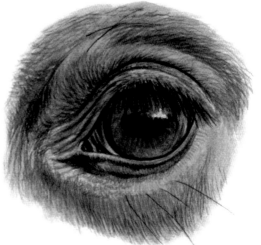

STEP 4 I begin to build up the bony areas surrounding the eye with strokes of burnt sienna and raw sienna. I achieve this with lighter, less layered washes directly below the bottom eyelid and a darker area below that. I continue to add detail in and around the eye and vary the length of my brushstrokes, which radiate outward from the pupil. I also darken the creases with diluted Payne's gray. Small gray and black strokes on the lower eyelid add definition.

STEP 5 I add a titanium white highlight above the pupil as well as small strokes in the lower eyelid. I also build additional layers of the ultramarine blue highlight and darken the pupil with lamp black. I allow drying time before painting in more eyelashes with lamp black on a dry brush. I deepen the radiating strokes of burnt sienna and raw umber as I make sure the outline of the eye is a nice even oval. I use smooth strokes to further outline the upper and lower lid. I darken the crease lines of the eyelid with raw umber. Finally, I add the long lashes above and below the eye in smooth strokes of lamp black with almost no water.

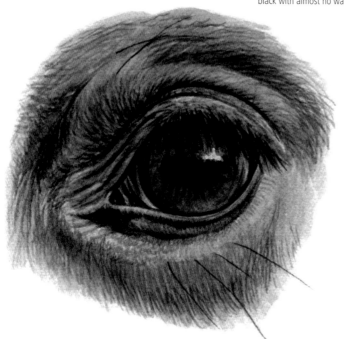

STEP 6 Everything comes together and darkens with added washes in the final stages. I add about three more washes each of burnt sienna and raw umber in the darker areas above the creases to outline the shape and give it dimension. I give the eye two or three more layers of the blue highlight and a few more layers of black until the pupil color is flat. Several more layers of the white highlight heighten the contrast between it and the dark pupil and brown tones of the cornea.

You'll use these basic six steps for every equine painting, especially a head study. Of course, if you are painting the whole body of a horse or an action shot, the eye area will be much smaller. You will not be able to show as much detail, but the basic anatomy and pupil shape will remain the same.

A QUICK LOOK AT OTHER EYES

Eyes vary widely from horse to horse and breed to breed. It is important to observe the differences so you can accurately portray the shape and structure of each horse's individual eye and expression. Here's a quick look at five additional types of eyes you may finding yourself painting.

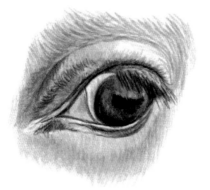

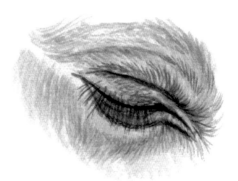

When the eyeball moves back in the socket, a white band where the eye ends is clearly visible. This gives the horse a worried, startled, or scared look or may just mean the horse is looking behind him.

This horse is asleep or blinking. Horses sleep for a very small number of hours each day and often sleep standing up. Notice the eyelashes sprout from a fairly large area on the upper eyelid. Put eyelashes in one at a time with lamp black and a #2 brush.

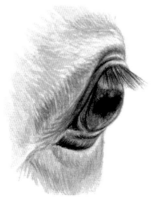

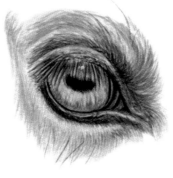

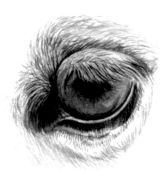

Painting a horse's eye from a front view requires different shaping and shading. Also notice that you can clearly see the pupil looking forward and the blue highlights at the top of the eyeball.

Blues eyes are also called "wall eyes" in horses. This particular horse is a Paint-Arab mare, and I used very light strokes of cerulean blue with a #3 brush for her eye. Other horses have eyes that are part blue and part brown.

This gray horse has white eyelashes and a rounder eye. Small ponies and Paint or Appaloosa horses often have these light eyelashes. You can use masking fluid (see page 6) to preserve the light areas for the lashes.

Tip!

A horse's eye reflects many details and light at close range. In a photograph, you may see a reflection of yourself holding the camera. Remove these distractions in your preliminary sketch.

INTRODUCTION TO EQUINE PHOTOGRAPHY

No matter how familiar you are with horses, the importance of working from photos cannot be overstated. Photos provide a stationary reference of the needed details, from a horse's anatomy, coloring, and tack to a rider's expression, pose, and apparel. If you're not a horse owner, don't worry. Horses are everywhere! Take a look around and take some photos at a summer fair, a rodeo, a horse show, or even in crowded city streets, where you might find a horse-drawn carriage or a mounted police officer.

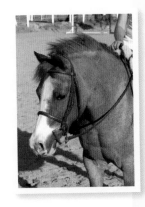

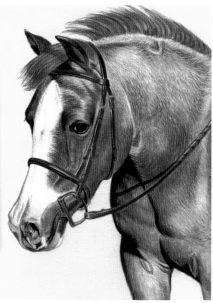

Tip! If you find a photo on the Internet that you want to paint, obtain permission from the photographer before using it as a reference.

I removed the distracting background, shadow, and the visible parts of the rider and saddle for the painting.

When taking photos, try different angles and heights. Ask the owner to step into the photo and pose with or ride the horse at varying gaits. Think about composition and lighting. Can you clearly see the correct coloring of the horse? Are shadows obstructing any details? The primary purpose of the photo is to capture a good likeness of the horse and rider. You can always change the background for your painting, as I did in these two examples. Remember, memorable photos make memorable paintings!

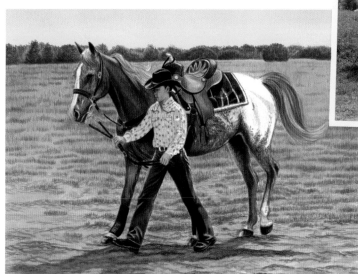

For the painting, I used brighter tones and added a more serene background.

PORTRAIT PHOTOGRAPHY

Digital photography allows you to take a large number of photos at once, so you have plenty of choices when later selecting an image to paint. I'll easily take 100 to 150 shots when photographing a horse I plan to paint. Here are several examples from a photo shoot for my painting titled "Portrait of Terra and Marian."

ICON GUIDE

This photo would make a good painting.

This photo would not make a good painting.

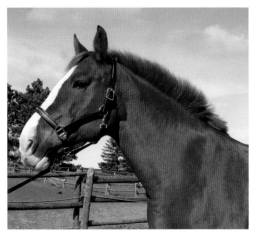

This photo is from too low a vantage point.

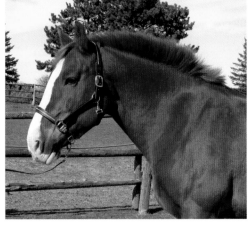

For a head and neck photo, full profiles are not as attractive as three-quarter profiles. If you were going to paint this background, notice that a tree seems to sprout from the horse's neck.

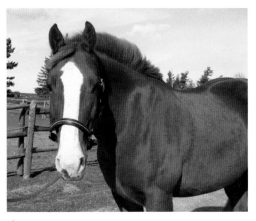

This shot is too head-on, and you are getting too many dark shadows on the neck.

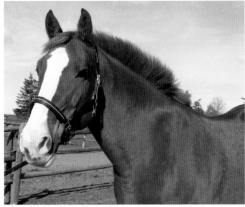

This is an attractive three-quarter profile. Her ears are up, she has a nice expression, and the sun is reflecting off her bright, shiny coat.

Tip!

Taking treats with you to photograph a horse is often counterproductive. The horse will likely follow you around, and you won't be able to get enough distance between you and the horse for a good photo. Instead, have someone stand behind you and try to get the horse's attention while the owner handles the horse.

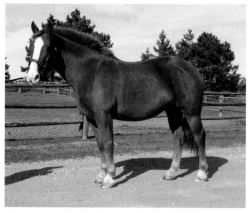

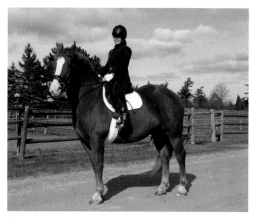

 For a full-body photo, a full profile often works better. It's nice that you can see all four hoofs so you have separation in the legs.

 This is almost a great riding shot, but the horse's ears are back.

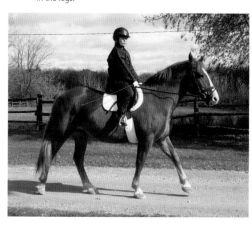

◀ This candid shot is relaxed, and the shadows going to the left create some drama. You could easily remove the power line in the background for a painting.

▼ This is the photo that I eventually used for my painting. Not only does the photo capture the farm in the background, you can clearly see the detail of Marian's riding gear and Terra's tack. Both the horse and rider have pleasant expressions.

Turn to page 36 to paint Portrait of Terra and Marian!

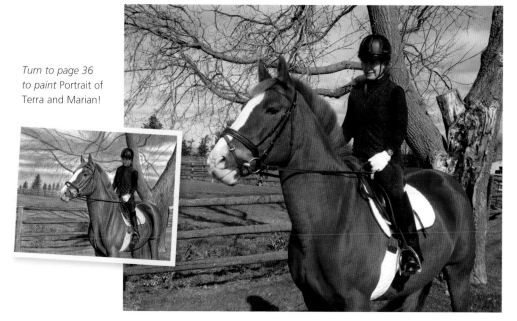

PHOTO COMPOSITES

Computer composites are a fast, easy, and accurate way to make a nearly perfect photo reference even better. You'll save time not having to draw and redraw trying to merge two or more images into one pencil sketch. I use photo editing software, such as Photoshop, to combine elements from various photos, add a more appealing background, or even to mix and match different parts of the horse from different images. For my painting titled *Autumn Splendor,* I took several photos of my Arabian horse Copper as he frolicked in his paddock. Since I didn't capture the perfect photo that I wanted to paint, I created one on the computer from the two photos below.

SELECTING PHOTOS FOR A COMPOSITE

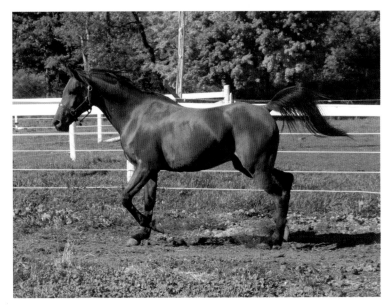

In this photo, I love the expression on Copper's face and the way tendrils from his mane fly up and over the crest of his neck. I also love the look of his tail and the reflections on the black hair. The beautiful autumn colors create a perfect background. What I don't love is the position of his legs. It is always more flattering when the front leg in the foreground is extended.

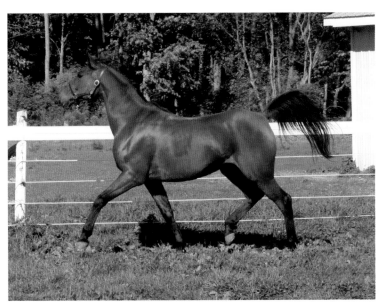

This second photo gives me the leg extension I am looking for, but I do not like that his head is slightly tilted away from the camera. In this instance, I decide to paste the bottom half of Copper from this photo onto the first photo above.

CREATING THE COMPOSITE

Now that I've selected the two photos I want to use, it's time to merge them. I open them both in Photoshop. In the second image, I roughly outline the bottom half of Copper that I want to transfer using the lasso tool. I copy this selected area and move over to the first photo, where I paste it in as a new layer. This first photo now has two layers, one with the main image and one with the bottom half of Copper.

On the main layer, I dial down the opacity to about 50 percent so I can clearly distinguish the layers from one another. Moving back to the second layer, I use the scale tool to adjust the size of Copper's bottom half to match the top. Then I align the two layers. You can erase any parts of the secondary layer that you won't need so that more detail shows through on the main layer. Once you increase the opacity on the original layer back to 100 percent, you can flatten the image and save it as a new file.

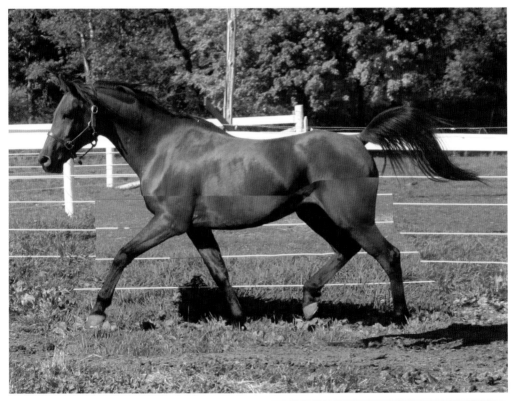

The composite does not have to be finished work. Only spend as much time as needed to create a reference image that gives you the detail you need. In this composite, I haven't lined up the fence or Copper's chest where the two images meet. These are details I can fix in my pencil sketch.

Tip! *When you're creating a photo composite or simply selecting a reference photo, don't worry too much about the background. You can always change or eliminate it for your painting.*

Turn to page 40 to paint Autumn Splendor!

SHOWDIN

This people-loving horse is very affectionate and endearing. His name is Showdin, and he's a warmblood Trakehner yearling owned by a friend of mine. His majestic look and beautiful expression are striking. He has a wonderful temperament and is amazingly calm and gentle, almost as if he's a big puppy dog.

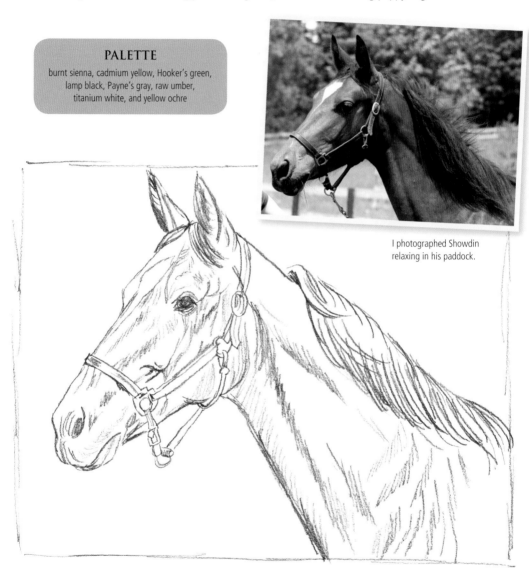

PALETTE

burnt sienna, cadmium yellow, Hooker's green, lamp black, Payne's gray, raw umber, titanium white, and yellow ochre

I photographed Showdin relaxing in his paddock.

STEP 1 Notice that all of the shapes of the horse's head are easily captured in three circles, two triangles, and the ovals for the ears. I draw the halter fairly closely from the photo so I get the details right, from the buckle to the fittings. I also add a few guidelines for the neck muscles.

Tip!

You are sure to paint a variety of halters when your subjects are horses. Pay attention to the buckles, the fittings that hold it together, and the material, such as leather or nylon. Some halters even have brass nameplates.

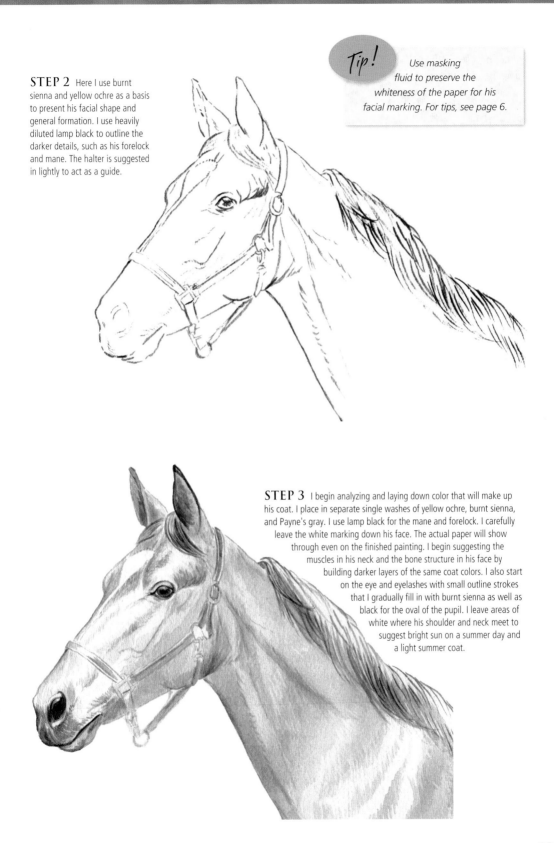

STEP 2 Here I use burnt sienna and yellow ochre as a basis to present his facial shape and general formation. I use heavily diluted lamp black to outline the darker details, such as his forelock and mane. The halter is suggested in lightly to act as a guide.

Tip! Use masking fluid to preserve the whiteness of the paper for his facial marking. For tips, see page 6.

STEP 3 I begin analyzing and laying down color that will make up his coat. I place in separate single washes of yellow ochre, burnt sienna, and Payne's gray. I use lamp black for the mane and forelock. I carefully leave the white marking down his face. The actual paper will show through even on the finished painting. I begin suggesting the muscles in his neck and the bone structure in his face by building darker layers of the same coat colors. I also start on the eye and eyelashes with small outline strokes that I gradually fill in with burnt sienna as well as black for the oval of the pupil. I leave areas of white where his shoulder and neck meet to suggest bright sun on a summer day and a light summer coat.

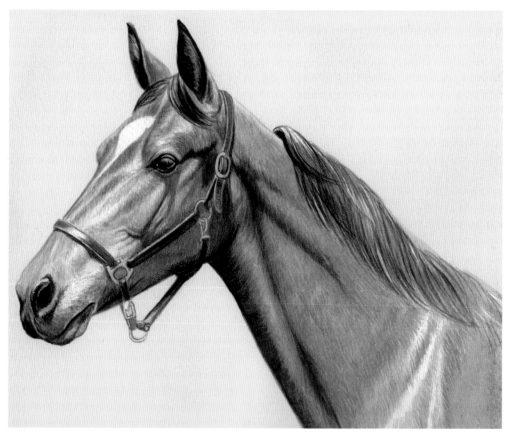

STEP 4 I lay down a preliminary light wash in the background using yellow ochre and burnt sienna, colors I've already used in the neck and face. For his mane, I add more strokes of lamp black on a dry brush. Some hairs look sort of windswept. I darken the muzzle area and try to suggest the shape of his lower lip and mouth. I also suggest the dark shadows in his face, on his lower jaw, behind his ear, and down the muscles of his neck with strokes of raw umber. The halter is developing with light strokes of raw umber. I leave the top edge of the leather very light to suggest a highlight, and I leave a bigger highlight on the noseband for the sun's reflection. For the details and highlights of the halter, I add a touch of Hooker's green to the yellow ochre, cadmium yellow, and titanium white I use to portray the brass.

ABOUT TRAKEHNER WARMBLOODS
The breed you're now painting, the Trakehner European warmblood, originated on an East Prussian farm in Trakehnen in the 18th century. A "warmblood" horse is a mix of hot-blood horses, such as the high-energy Thoroughbreds and Arabians, and cold-blood horses, such as the mild-mannered and heavier Clydesdales. A small East Prussian breed, the Schwaike, a transportation and agricultural work horse, is part of the origin of the Trakehner breed.

STEP 5 Now it's time to extensively develop the details with short tiny brushstrokes built up in layers. I place heavily diluted washes of burnt sienna on top of the detail on the neck to solidify and darken the colors, as well as tie them together with the other planes of the face. I further darken the mane by building up one hair at a time in lamp black. I give extra attention to the hairs laying slightly out of place for more realism. For the background, I once again use yellow ochre washes in layers, letting one dry completely before darkening other areas. I finish by adding even darker washes in diagonal corners for depth. This painting has about four washes in the background.

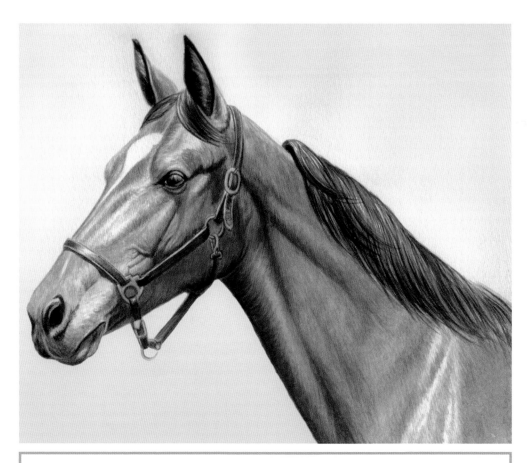

DETAIL 1

For the small stitches on the halter noseband, use a size 1 brush to build up small white strokes again and again as they dry. The layers imitate how the thread lies on top of the leather. Gouache is useful here as it is more opaque than watercolor. I normally use a magnifying glass on a loupe for consistency in size, shape, and direction.

DETAIL 2

It is important to get the anatomy of the face correct when doing a head study. There are many veins, protruding bones, and contours in the face along the muzzle and above and behind the eye. There are usually veins visible in the face below the bony structures and around the nostrils. I define these areas in dark shadows of raw umber that I build one layer at a time.

ITCHY FOOT

The natural, shiny coat of Sienna Noble Lady comes through beautifully in this painting, which is a favorite of mine. Sienna Noble Lady was my mare's first foal, and you'll have another opportunity to paint her in the First Born project that begins on page 30. For this painting, I zoomed in on a photograph, taken on a bright summer day when she was two years old, to show the detail of her anatomy. Here, she scratches her fetlock with a partially opened mouth. Horses scratch this way, as they do not have hands to reach for an itchy spot.

PALETTE

alizarin crimson, bright green, burnt sienna, cadmium yellow, lamp black, raw sienna, raw umber, titanium white, ultramarine blue, viridian green, and yellow ochre

STEP 1 In this pencil sketch, I develop very basic guidelines to show where the various muscles, tendons, and hair appear. The curves that form her neck are almost parallel but narrow at the base of her throat. I also add guidelines for the bright highlights, so I know not to paint over these areas.

STEP 2 I begin roughing in light layers of yellow ochre. Once this dries, I lightly add burnt sienna on her jowl and areas of her face. To define the ridge of muscles in her neck and leg, I use long strokes of raw sienna. Then I add smaller strokes of burnt sienna that radiate outwards from the defining stroke. I paint in very light areas of her mane, one long hair at a time, with lamp black. As her mane gradually darkens, these first layers will add dimension. As a bay-colored horse, her legs gradually change from a reddish color to black. I carefully place black strokes extending above the knee and surround it with diluted burnt sienna.

Tip! It is safer to leave the white highlight areas a bit larger than you might need them to be and gradually make them smaller. You can always darken them later with a diluted wash.

STEP 3 I begin to darken every element except for the white areas by building layers. In areas of intense shadow on her face, I use a mixture of alizarin crimson and ultramarine blue. To vary the bright highlights on the mane and legs, I mix lamp black with more water for lighter values. Then I build layers with less and less water to darken the color. The shadow on her leg in the background is almost pure black. In the foreground, the bright sun clearly defines her leg muscles, which I darken with raw umber. Strokes of burnt sienna radiate outward to create dark shadows. I also lightly outline her wrinkled muzzle and her partially opened mouth in diluted lamp black. The grass builds in layers of bright green gouache as I add a touch of ultramarine blue to the shadow.

Tip! Instead of using bright green gouache for the grass, you can mix cadmium yellow and Hooker's green watercolor paints.

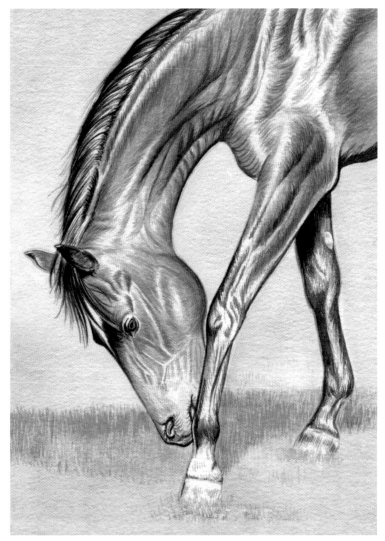

STEP 4 I darken the shadow on her belly with a mix of lamp black and raw umber. I later add pure lamp black on top of that. Her hooves reflect the bright light, so they are given definition with small vertical strokes in yellow ochre and lamp black. I darken the legs with extra layers of lamp black in strokes small enough to leave areas of paper showing for pristine highlights. I add her small eyelashes in thin white strokes. In the areas of her coat that are getting too red, I add a wash of cadmium yellow. The chestnut, a small oval-shaped, callous-like area, on the leg in the background is visible above her knee, so I add a bit of detail with a few small strokes of lamp black. I layer in more bright green for the grass and viridian green for the shadow. I build darker patches in the grass that will eventually show texture.

DETAIL 1 I patiently add small strokes to suggest various hair textures with gradually increasing amounts of burnt sienna and less and less water to make the paint more intense as the layers build. The strokes vary in both length and direction as I follow the patterns of hair growth.

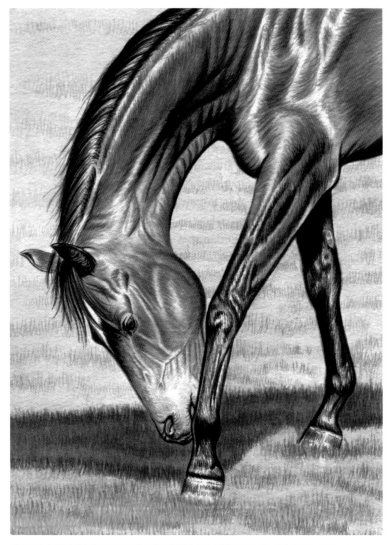

STEP 5 Being careful not to muddy or over saturate the colors, I add the final layers. I finish the grass by adding brushstrokes of diluted viridian green. My strokes go in an upward direction, similar to the way the grass grows, and they are not all parallel. The shadow in the grass gets light washes of viridian green, and I'm careful to use light pressure so I don't disturb the multitude of layers below. I darken the shadow on the background leg with more layers of lamp black and repeat for the fetlock on the foreground leg. This intense black comprises six to 10 layers altogether. I use raw umber to define the darkest areas of her jowl while leaving her muzzle very light. I darken the inside of her ears with more layers of lamp black. The light areas are completely untouched at this end stage. The actual white of the paper shines though in contrast to the heavily layered areas.

DETAIL 2 I use diluted lamp black, almost a mid shade of gray, for the wrinkles and contours of the lips, mouth, and nostril. A small dab of diluted alizarin crimson in her mouth suggests her tongue. I leave her main muzzle area fairly light as the highlight there was substantial. To finish, I outline the main lines of her mouth and nostril with lamp black that's nearly dry.

DETAIL 3 On her neck, I use strokes of alizarin crimson mixed with ultramarine blue for an intense purple. These strokes radiate upwards from the dark neck strokes and stop just before the white highlight at the top of her neck.

FIRST BORN

Of the approximately 1,000 paintings I have done since I started painting horses in 1989, this is my favorite. My filly, Sienna Noble Lady, was only two days old. My husband and I were there when our mare, Cinnamon Lady, gave birth to her, and her beauty and spirit were evident from the first day of her life. This painting is special to me for many reasons. My husband and I have owned Cinnamon Lady since our children were small, and she's always been safe and reliable for any level of rider.

PALETTE

burnt sienna, burnt umber, cadmium red, cadmium yellow, lamp black, Payne's gray, raw umber, titanium white, ultramarine blue, and yellow ochre

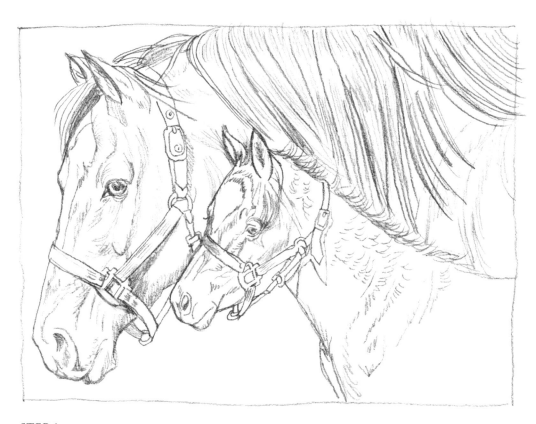

STEP 1 I outline the heads and halters of the mare and foal to help me plan the painting. I sketch in the main areas of the mare's mane and leave light areas for the highlight. The foal has a fuzzy coat, so I add a few small strokes on her neck to help me add the right detail in the painting stage.

Tip! The light source is coming from the far left, which means the shadows develop on the lower sides of the halters and the underside of their jaws.

STEP 2 Their red bay coats are shining brightly with strong highlights, so, as usual, the highlights remain unpainted. I lay down light washes of yellow ochre for the coats. Then I add strokes of almost pure burnt sienna on top of the washes once they are dry. I gradually darken the facial bones with additional strokes of pure burnt sienna on top of the earlier strokes. Notice that I use crosshatching on some of the lines on the cheekbones. I lightly rough in the halters with ultramarine blue and suggest the nylon webbing with darkened lines of Payne's gray. I use diluted lamp black for the manes and leave a large white area in the long mane of the mare. The eyes are fairly well developed in this early stage because they are so important to their expressions.

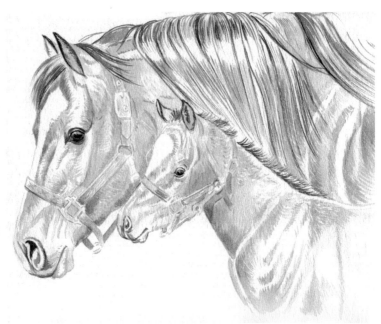

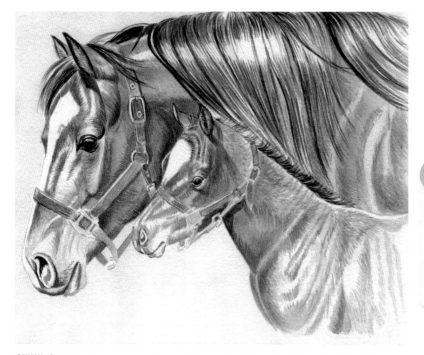

Always keep cotton swabs on hand to blot colors that go on too intensely.

STEP 3 I darken the mare's mane in long strokes using lamp black. I let each layer dry before adding the next and carefully leave white highlights throughout. The filly is not yet old enough for a thick mane and forelock, so I use light, short strokes of lamp black. I follow the direction of hair growth on their necks and shoulders with burnt sienna mixed with yellow ochre. Light strokes with an upward curve suggest the filly's fuzzy coat. The halters are taking shape with ultramarine blue plus layers of cadmium yellow and yellow ochre for the brass hardware and fittings. I add washes of Payne's gray in the mare's mane to separate out the sections. I develop the muzzles with layers of Payne's gray and lamp black. I add yellow ochre higher up where the muzzles meet the coats. I suggest small details and veins on the mare's muzzle by outlining the structures and placing a tiny shadow of raw umber on the underside.

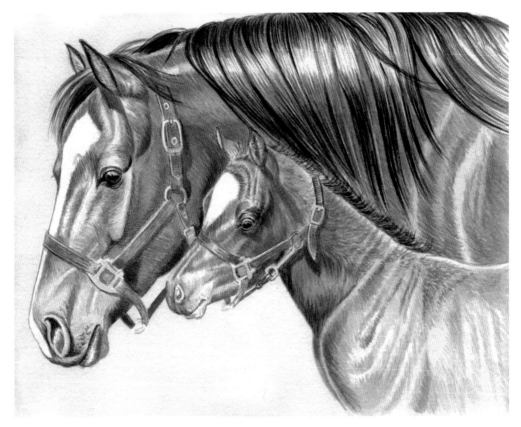

STEP 4 I add the first wash of yellow ochre with lots of water to the background, but it will hardly show until two or three more layers are later added. Each wash is allowed to dry thoroughly before adding the next. I add shadows of burnt umber on the mare's jaw and under the halter, as well as on the filly's shoulder area. I continue with burnt sienna and burnt umber strokes on the necks and gradually darken the black strokes of the manes. The mare has a large white blaze that goes all the way down her face, so I allow the pure white paper to show through. I put small strokes of diluted burnt sienna on the outer edge of this white marking so it doesn't blend into the background.

DETAIL 1 I add a bit of watered down cadmium red that looks pink to the mare's nose to suggest the curves and shapes on her muzzle. Small lumps appear above her lip where the whiskers grow. I lightly paint the shadows of these lumps in Payne's gray. I also darken the nostril shadows until they are almost black.

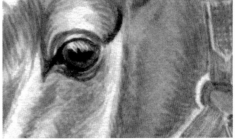

DETAIL 2 I darken the pupils of the eyes with lamp black and further fill in the eyelashes with white. Horses' eyelashes are actually black, but they reflect a lot of light. They sometimes appear very light in the bright sun, so I often put them in with white.

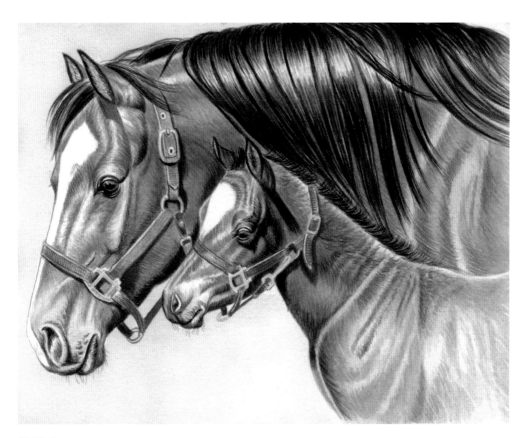

STEP 5 It's time to darken the colors and add the finishing details. The background needs about four more light washes of diluted yellow ochre and burnt sienna. Let each layer dry thoroughly before adding the next. The halter hardware and buckles get more layers of yellow ochre and cadmium yellow with Payne's gray to darken the details. I add small white brushstrokes to the filly's fuzzy mane that curls out of her neck. The mare's mane gets tiny black lines on top of the bright highlight. I add tiny whiskers, one hair at a time, in heavily diluted Payne's gray (almost 95 percent water) to both muzzles. The small strokes radiate outward from the chin in a tapering motion. I also add light strokes of burnt sienna for the hair in their ears. I finish the mare's eye with a small white highlight and small strokes of lamp black on top of the white eyelashes. Finally, heavy strokes of raw umber finish the darkest shadows.

Tip!

The key to getting flat washes is patience. Constantly move the paint around until it is uniform. If color pools even for half a minute, it stains the surface and cannot be removed.

GETTING TO KNOW THE HORSES

As I've mentioned, this painting holds special meaning. I even use it as my logo. The mare, Cinnamon Lady, was a wonderful show hunter in her early years. She is a Quarter Horse, and her father was a World Champion in 1995. She's been featured in a multitude of licensed products as well as in an episode of an Ontario children's television show. The filly, Sienna Noble Lady, is an appendix Quarter Horse. Her father was Noble Lord, a thoroughbred with racing bloodlines. More than their breeding, however, I care about their kind, gentle temperaments.

BUCKLE UP

If you are familiar with riding horses, you may notice a safety issue in this painting. The little girl does not have control of the reins as she buckles up her helmet. Of course, in the photo, you can see that the mother is holding the pony steady, but that's one of the elements I decide to eliminate from the scene.

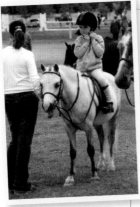

Ignoring the clutter in the photo, I decide to concentrate on the girl and her pony.

STEP 1 If you plan to paint on top of your sketch, draw very lightly because the pony is light-colored. You'll need to constantly erase your guidelines to prevent pencil smudges and stains.

STEP 2 Using Payne's gray, I lightly outline the shape and start to fill in some of the shadows and darker areas of this dappled gray pony. I outline the tack in one light brushstroke of raw sienna and build about three layers of raw umber for the girth strap under the pony's belly. I show the wrinkles and outlines of the girl's riding breeches as well as the stirrup and boot with raw umber in very light brushstrokes. I build layers of Payne's gray and lamp black for her jacket and carefully leave white highlights to suggest the wrinkles and lapel. Finally, I rough in a few blades of grass in Hooker's green.

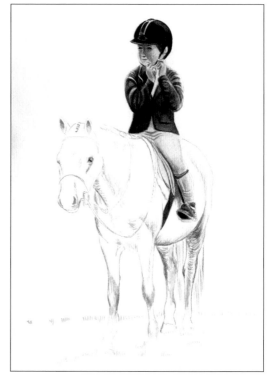

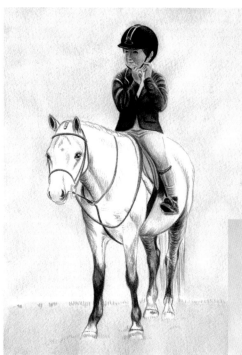

STEP 3 I lay down the first light washes for both the sky and grass using cerulean blue and Hooker's green. I start to develop the darker parts of the pony's legs with lamp black, and I pay careful attention to how the black hair mixes with the white. This pony is almost pure white, so I leave large areas untouched to keep the paper clean. I easily suggest his neck, face, eyelashes, and braided mane with minimal strokes of Payne's gray. I use one or two light layers of alizarin crimson to depict the pinkness of his muzzle. I lightly add lamp black and a small amount of yellow ochre to his hooves. The tack, saddle, and saddle pad develop with strokes of raw umber. I also add strokes of raw sienna to the underside of the brow band with light strokes of raw umber to suggest a shadow. The creases of her riding pants darken with additional strokes of raw umber on top of the earlier strokes.

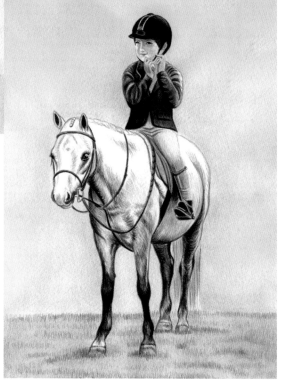

STEP 4 I finish the sky and grass with two to four more washes and add small, upward strokes into the grass to suggest individual blades. I add many more short black strokes to the pony's legs, chest, neck, and belly. Having plenty of cotton swabs on hand helps to prevent these strokes from becoming too dark and to blend the gray areas. I add one more dot of lamp black to the pupil of the pony's eye for greater contrast next to the light eyelashes. A series of tiny strokes in lamp black outlines the lower eyelid. I darken the leather, especially the lower edges, with raw umber and outline the buckles of the bridle with titanium white. For the braids on the reins, I use tiny strokes of raw umber. I finish the rider's jacket and helmet by layering ultramarine blue and Payne's gray in the highlight areas. Lastly, I add lamp black to the bottom of her boot. Once the painting dries, I scan it into the computer and lighten the girl's face by adjusting the curves a small amount.

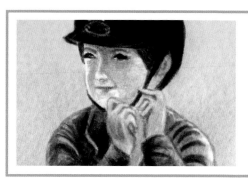

DETAIL 1 The rider is the hardest part, so I concentrate heavily on her. I use cadmium red washes to suggest her facial features, lessening the red with washes of yellow ochre. I use raw umber for a light shadow under her helmet brim and for the outline of her fingers. A single, smooth stroke of alizarin crimson creates her lips. For her eyes, I use about three layers of Payne's gray with drying time in between. Her hair is pure raw umber with strokes of Payne's gray to differentiate the sections. Her helmet needs about six layers of lamp black, and I'm careful to leave the highlight areas white.

PORTRAIT OF TERRA AND MARIAN

This painting combines a beautiful horse, Terra Firma, and rider, Marian, with a scenic fall background. The challenge is getting all of the details, from the background to the foreground, to work together, as well as to accurately portray both the rider and her clothing and the horse and her tack. Serious riders are intensely fashion conscious. Terra is wearing her dressage tack, which is equipment specifically designed for the discipline of dressage, a type of competitive horse training.

PALETTE

alizarin crimson, bright green, burnt sienna, cadmium red, cadmium yellow, cerulean blue, Hooker's green, lamp black, Payne's gray, raw sienna, raw umber, titanium white, ultramarine blue, viridian green, and yellow ochre

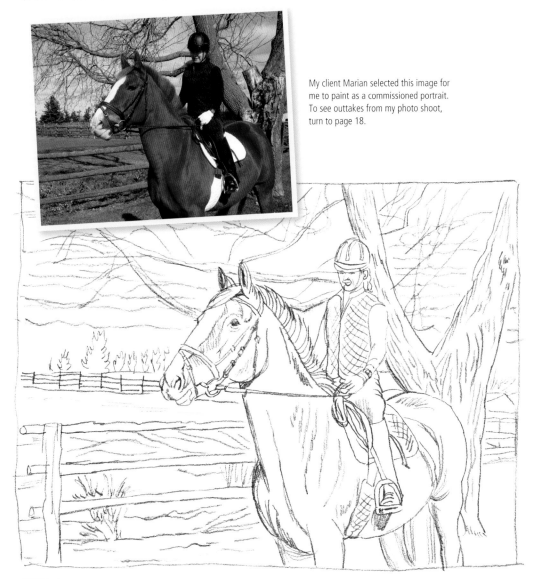

My client Marian selected this image for me to paint as a commissioned portrait. To see outtakes from my photo shoot, turn to page 18.

STEP 1 This is a good illustration of how the sketch can help capture the realism of the piece. For example, the branches behind the horse are a big tangle, as is the complicated shadow on the ground through the fence. Just a few pencil lines can remove the uncertainty of exactly where those shapes should go and give you confidence to simplify the painting process. I decide not to include the stub from the cutoff limb in the middle of the foreground tree to make it more attractive.

DETAIL 1 In a portrait, the face of the rider is always important, so I develop this area extensively early in the process. If something goes wrong, I can start again and waste the least amount of time redoing the rest of the work. In this step, I lightly outline Marian's face in diluted Payne's gray. Then I add shadow areas with strokes and washes of diluted cadmium red. I don't define her eyes yet, but I do suggest them with darker strokes of Payne's gray. I use about four layers of diluted cadmium red for the shadow falling from her helmet, which I paint in varying intensities of lamp black. I leave parts of the paper untouched for the helmet highlights. Thin lines of alizarin crimson create her lips, I and leave a highlight in the middle of her bottom lip.

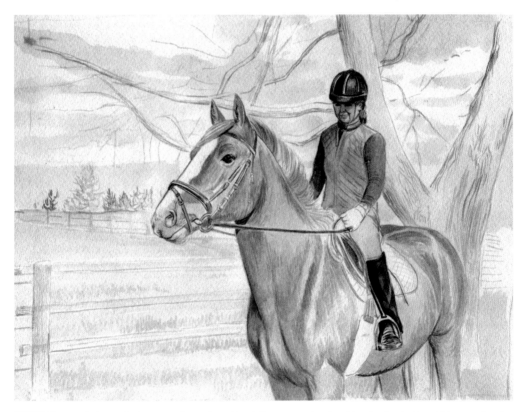

STEP 2 I start blocking in the beginning colors. Light washes of ultramarine and cerulean blues develop the sky, and I leave patches of the white paper for the clouds. I'll finish the sky before developing the smaller branches so I don't have to paint the sky around them. I use very light washes and strokes of burnt sienna for the horse, raw umber for the bridle, and lamp black for the rider's clothing. I carefully leave the white of the paper showing on the horse's face and saddle pad and Marian's glove. I outline the main areas of the grass in bright green and use very light strokes of viridian green for the background trees. For the foreground tree and fence, very light strokes of Payne's gray (about 97 percent water) provide an outline as well as rough color and texture. I leave a blank area on the right for the barn.

Tip! *In the early stages when you are using more water than paint, a big blob of water may come off the brush. Simply blot it with a cotton swab or tissue.*

STEP 3 By slowly building strokes of burnt sienna in layers, I deepen the rusty chestnut color of the horse's coat. Additional layers darken the shadows. I use both lamp black and Payne's gray in crosshatched strokes on Marian's vest. I build about eight layers of black on the clothing and 12 on the boot. The grass is building in combinations of yellow ochre and Hooker's green, and I continue to alternate layers of the two blues for the sky. Though the background trees and fence are untouched in this step, I add shadows and texture to the foreground fence and tree using Payne's gray. Light strokes of yellow ochre on the tree suggest moss. A light outline in Payne's gray develops the barn and trees in the far right.

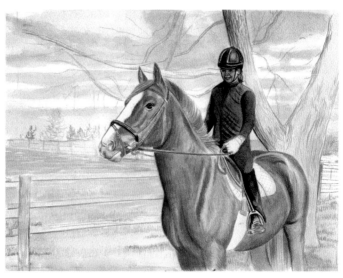

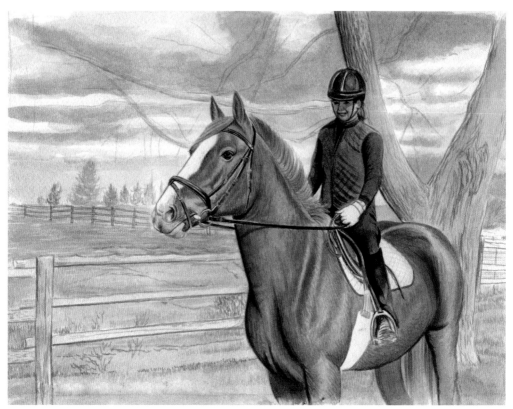

STEP 4 The rider is far enough along that I can leave her untouched for now. The shadows on the horse's coat darken with strokes of burnt sienna, plus a touch of raw sienna for the front chest muscle. I add a light wash of cadmium red and cadmium yellow for unity. I add two more layers of raw umber to the reins. One dark stroke curving down from the rein creates a shadow on the horse's neck. I start adding dead weeds with a 50-50 mixture of yellow ochre and raw umber. The fence darkens with Payne's gray, which I also use to build more bark texture on the foreground tree. I darken the background trees with small strokes of viridian green. In the sky, I add depth to the clouds with alizarin crimson and ultramarine blue. Finally, I use Payne's gray to lightly add the shadow of the foreground tree that falls on the grass.

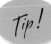

STEP 5 I finish the grass with yellow ochre and Hooker's green and the dead weeds with yellow ochre and raw umber. Once the grass dries, I darken the tree's shadow with Payne's gray. After a few final touches of blue dry in the sky, I start building the smaller branches of the tree using Payne's gray. I'm careful not to disturb the layers of paint in the sky. I continue using Payne's gray to finish the barn, bark, and background fence as well as to suggest wood grain on the foreground fence, which gets a touch of yellow ochre to dull the white highlights. I finish the background trees with viridian green. Marian's glove needs light strokes of Payne's gray to separate her fingers. I also add her watch in lamp black with a highlight for the face. Fairly heavy layers of raw umber define Terra's muscles. I add a triangular-shaped shadow for Marian's foot in diluted Payne's gray. I also add a small white highlight to the horse's eye. Finally, I outline the Payne's gray bit in the corner of Terra's mouth in lamp black.

DETAIL 2 The final strokes of lamp black (about a 50-50 ratio of paint to water) finish the quilted details of Marian's vest as I carefully paint on top of earlier strokes.

DETAIL 3 Small stokes of Payne's gray on top of the otherwise untouched white paper suggest the quilting on the white saddle pad and girth cover.

AUTUMN SPLENDOR

It's time to paint another one of my own horses. This is Copper, an Arabian gelding. I photographed him in the fall as he frolicked in his paddock after coming home from a 25-mile competitive trail ride. He was 12 years old at the time. You can clearly see the beauty of the Arabian breed in this photo and painting. The arched neck, slightly dished face, high-set tail, and short back are typical of the breed.

PALETTE
burnt sienna, cadmium red, cadmium yellow, lamp black, Payne's gray, raw umber, titanium white, ultramarine blue, and yellow ochre

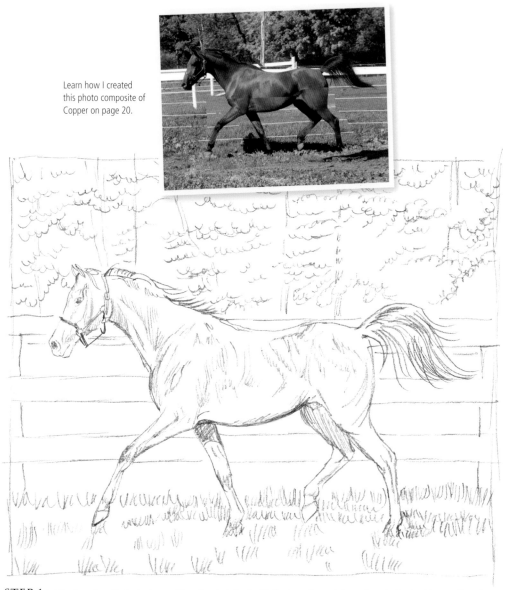

Learn how I created this photo composite of Copper on page 20.

STEP 1 In this stage, I modify the background from the photo to simplify the fence line and change the wire fencing into wood boards. Adding the background features to your sketches helps you understand how the horse is placed within the environment. I suggest the highlights in his coat so I know where to let the paper show through in the painting. I also add the shadows on his background legs.

STEP 2 I begin with a 75-25 ratio of paint to water. I rough in the lightest values of his coat using cadmium yellow, burnt sienna, and raw umber. I leave highlights of blank paper amid the dark strokes of lamp black for his mane and tail. I continue with raw umber to define his muzzle and halter and lamp black for his nostril. I outline the tree trunks lightly in Payne's gray. The colorful foliage develops with Hooker's green and a 50-50 mix of cadmium red and cadmium yellow. The darker foliage reflects more layers of these colors. I lightly add the grass with Hooker's green, and I mix Payne's gray with ultramarine blue for Copper's shadow. The fence gets an outline of Hooker's green with the white of the paper left to shape the boards.

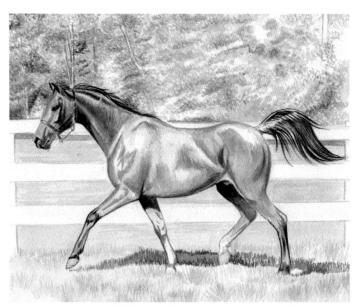

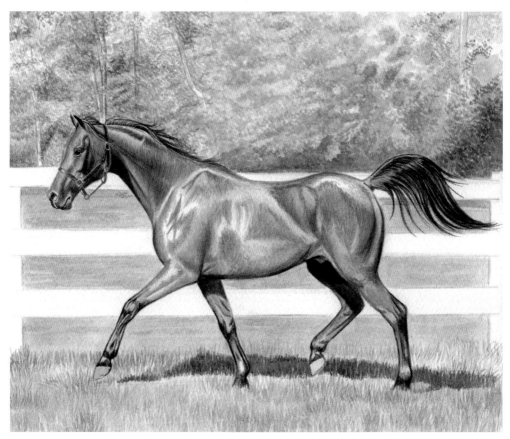

STEP 3 I continue darkening Copper's coat with burnt sienna. I use raw umber to develop his muscles, the shadows in his coat and his halter. I darken the lower half of his legs with lamp black and build additional layers in the darkest spots. For the shorter grass, I use horizontal strokes of yellow ochre, Hooker's green, and ultramarine blue. I use each color one at a time. I continue with Hooker's green to define the blades of grass in the foreground. I build on my previous layers of foliage with small dot-shaped strokes for the leaves.

STEP 4 I further define Copper's darkest areas with more and more layers of burnt sienna. I add individual mane and tail hairs in lamp black and carefully maintain the highlight areas. His two raised hooves show his toe clips and shoes, so I add those with diluted Payne's gray. I use a touch of titanium white in a 50-50 ratio of paint to water to lighten the area over his knees and fetlocks to suggest the round joints. I continue adding tufts of grass in the foreground with single strokes of fairly diluted Hooker's green. I use upward brushstrokes to mimic the direction of growth.

DETAIL 1 I use small dots to fill in the layers of foliage and build up more intensity in the Hooker's green and the mix of cadmium yellow and cadmium red. I introduce a mix of Hooker's green and cadmium yellow to suggest the depth of the forest. I also darken the trunks of the trees and add smaller branches with heavily diluted lamp black.

STEP 5 Additional strokes of burnt sienna continue to darken Copper's body. A final wash of cadmium yellow and cadmium red finishes the coat. I build more layers of lamp black as needed to darken his legs. I define his shadow with diluted ultramarine blue using upward brushstrokes to depict the grass where the shadow falls. With titanium white, I add highlights to the tail, mane, and hardware on the halter. I add more clumps of grass in the foreground with Hooker's green and use long horizontal strokes of viridian green to add depth to the background grass. I darken some of the tree trunks with Payne's gray and leave some lighter to suggest overlap. Carrying through colors from the previous steps, I intensify the fall foliage. Finally, I add titanium white over the boards of the fence with slight shadows in diluted ultramarine blue where the boards meet the posts.

DETAIL 2 The legs of every bay-colored horse gradually transition from a reddish color on the upper legs to black on the lower legs. I always study my photo references to know when and how to transition between the two colors. On Copper's front, extended leg, notice how the black spreads above his knee. I use small strokes that feather toward each edge to gradually bring the lamp black into the red. The color transition appears gradual instead of abrupt. Surprisingly, sometimes in the winter, these black points fade to reddish brown due to normal, seasonal color changes.

PASTURE PALS

I have so many favorite paintings, and this is another. These two Thoroughbred foals are socializing at the fence, so you have a chance to practice painting wood grains in addition to the contours and shapes of the foals' heads. It is rewarding to pay special attention to the surroundings and habitat of the horses.

PALETTE
alizarin crimson, bright green, burnt sienna, burnt umber, cadmium red, cadmium yellow, cerulean blue, Hooker's green, lamp black, Payne's gray, raw sienna, raw umber, ultramarine blue, viridian green, and yellow ochre

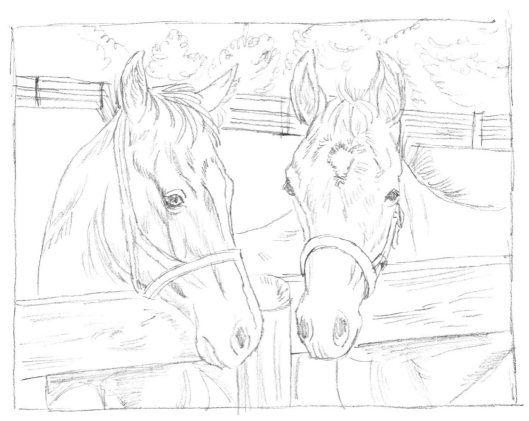

STEP 1 The pencil drawing helps identify the intention of the painting. In this case, it's the interaction between these two herd mates. The drawing also gives me a chance to figure out of the shapes of the trees and how they relate to the horses.

Tip!

The colors in this painting are very pure. Use each one right out of the tube or jar with very little mixing with other colors.

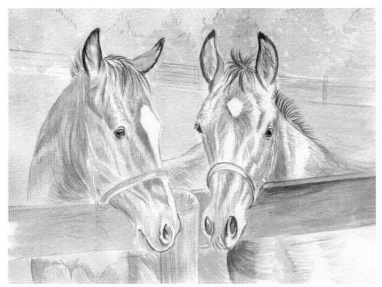

STEP 2 I start with washes of yellow ochre and then burnt sienna for the foals' coats. I use raw umber for the halters and leave the nosebands unpainted. I add a heavy stroke of burnt sienna for the eyes with lashes in Payne's gray. I use diluted lamp black for the manes, forelocks, outer ears, and nostrils. Single washes of bright green and cerulean blue color the grass and sky. I rough in the trees with Hooker's green and lightly paint the background fence in heavily diluted Payne's gray. The foreground fence shows knots, cut marks, and the top edge of the plank, so I develop color and texture with less diluted Payne's gray.

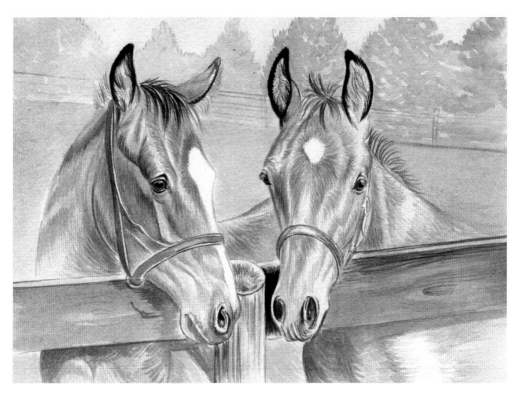

STEP 3 I further develop the horses' coats with layers of cadmium yellow, cadmium red, and burnt sienna. I suggest areas of shadow by building more layers of burnt sienna. I darken the areas of lamp black and continue darkening the halters with raw umber while maintaining the highlight on the nosebands. The background fence is untouched in this step. I add a small amount of detail to the trees, again using Hooker's green topped with a single layer of viridian green to suggest individual branches. I add one additional wash of bright green for the grass and cerulean blue for the sky. In small, increasing strokes of diluted lamp black, I depict the grain of the wood in the foreground fence with darker areas for the shadows.

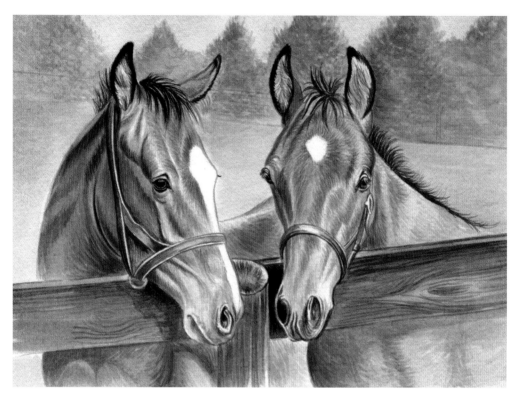

STEP 4 I gradually darken each element with increasing layers of color. The background fence is the exception as it disappears into the trees for now. I introduce raw sienna to define the chest muscles, and I use shadows of raw umber under the fence line to add depth. I use burnt umber to define the neck crease of the foal on the left and the bone structure and eye sockets in the face. Adding alizarin crimson to their faces brings out the redness of their coats. The details of the halters progress with diluted layers of raw sienna gradually moving toward the center highlight. I notice that the foal on the right looks too big and bulky. This is probably due to the camera angle in my photo. I begin to make his mane heavier to make his neck look thinner. I continue darkening the grass with horizontal strokes of Hooker's green. In the tree line, I add viridian green and ultramarine blue separately for depth. Individual strokes of lamp black add more detail to the grain of the wood fence. For the shadows on the fence, first I add raw umber and then Payne's gray.

DETAIL 1 Being able to develop realistic looking wood grain is important when your subjects are horses. Everywhere horses are, there is wood: barns, stall doors, and, of course, fences. Use your photo reference as a guide and experiment with different shades. For white fences, leave lots of paper showing through and add the grain in light washes of diluted gray and black. You can soften and add warmth to grays and blacks by adding raw umber. Or, you can cool them down by adding ultramarine blue. In this project, the four-board oak fence is painted black, but you can still see the detail of the grain. It's important not to let the fence get too dark and flat looking. That's why I started with diluted Payne's gray in Step 2 and gradually built up to lamp black using less and less water. There are a multitude of shades of gray and black on this fence. Patiently add one smooth stroke at a time to depict the texture of the grain, and you'll bring realism to your equine art.

Tip! *If you really love an image, experiment with re-creating it in different media, such as pen and ink, pencil, or colored pencil. It's a learning experience to realize the different ways to interpret the same subject.*

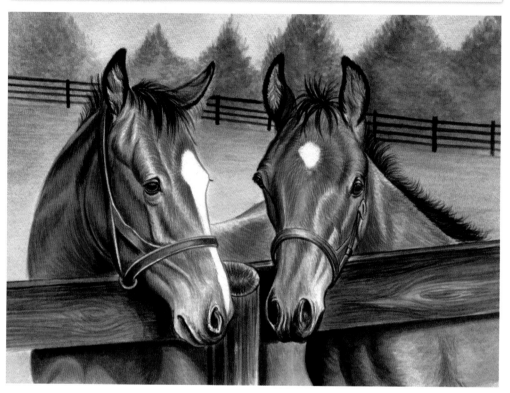

STEP 5 I finish the painting by adding burnt sienna, burnt umber, and raw umber in separate layers to the neck and chest areas. This adds muscle and shape definition. I darken the manes with heavy strokes of lamp black and continue to thicken the mane of the foal on the right. Washes of burnt umber finish the halters with darker strokes at the edges to suggest stitching. I add several strokes of lamp black to the edges of the foreground fence and darken the shadow to the left of the post, also with lamp black. This is one case where pure black shadows fit the image. I add more layers and strokes of viridian green and ultramarine blue to the trees. I wait for the trees to dry completely before adding the background fence back in with heavy strokes of lamp black that's mostly dry. Final washes in the sky and grass complete the painting.

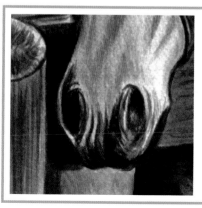

DETAIL 2 It's important to differentiate the foals' dark muzzle areas from the even darker tones of the fence. I outline both muzzles and nostrils with lamp black, which I also use on the interiors of the nostrils. The fence post shows long, narrow strokes of Payne's gray finished with lamp black. The shadow to the right of the post is almost pure lamp black. I make sure the nostril of the foal on the right stands out from this dark shadow by leaving a lighter area down the outside edge of the nostril. It is also important to correctly portray the anatomy of the mouth and muzzle. For instance, the outline of the lips is never a straight line. I use small uneven strokes of diluted Payne's gray, and I extend the color in small strokes to create a bit of texture on the upper lip. Noticing these details as you're studying the horse or your photographs is crucial to capturing a good likeness of the animal.

FUTURE PROMISE

In this painting, Showdin, the horse from the profile project that starts on page 22, is playfully enjoying his natural habitat. This is a scenic painting with a full background, and you have to be aware of the overwhelming presence of green in various hues, values, and intensities. Green is made up of a warm color (yellow) and a cool color (blue), so it is difficult to get just right without being overpowering.

PALETTE

burnt sienna, burnt umber, Hooker's green, lamp black, Payne's gray, raw umber, and yellow ochre

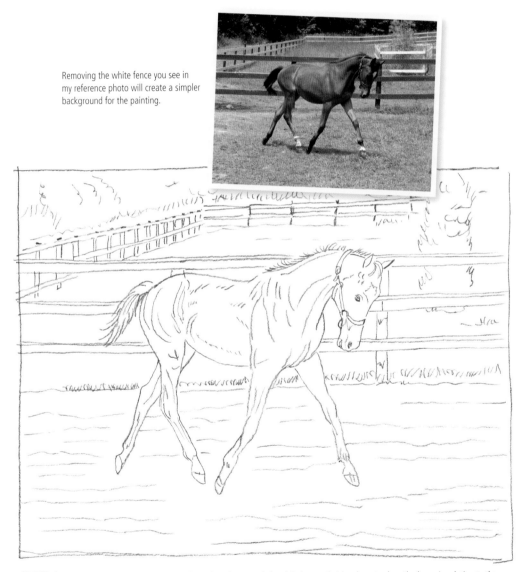

Removing the white fence you see in my reference photo will create a simpler background for the painting.

STEP 1 The fence line in this project is complicated, and my pencil sketch helps me decide where to place the horse in relation to the background. I add simple lines to show the highlights on his shoulder, hip, and stifle area. The small lines on the ground show me the transition between dirt and grass in the pasture.

STEP 2 I start by adding masking fluid in the background for the lighter areas of the tree line. You can also apply it on top of Showdin's facial marking if needed. I use burnt sienna for his coat and build up to about four layers for the darkest shadows in his musculature. The white paper remains blank for areas of highlight in his coat. For the shadow on the inner thigh of his back leg, I use raw umber. Lamp black in a 50-50 ratio of paint to water colors his mane, tail, and the black points on his legs. I add his halter with strokes of diluted burnt sienna. I rough in the fence using Payne's gray and lamp black separately. I begin building layers of foliage and grass with Hooker's green.

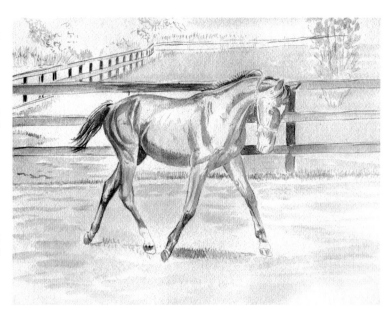

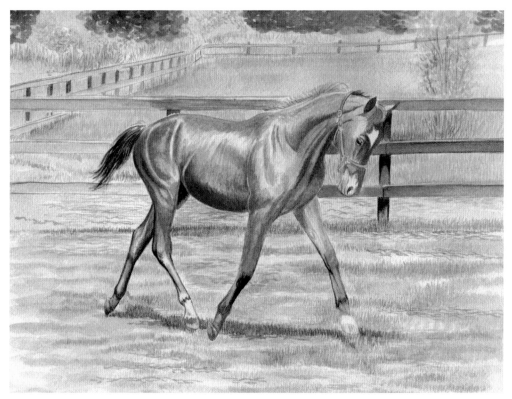

STEP 3 I add strokes of light yellow ochre to Showdin's body to unit the areas that are in dark shadow. I carefully leave the highlight areas untouched. I use lamp black for the muscles and tendons in his legs as well as the definition on his hooves. His mane and forelock were getting too dark, so I remove some of the black strokes using a damp cotton swab. I paint his halter with very light strokes of raw umber. I darken his shadow in the grass with Hooker's green and use small strokes of raw umber and burnt sienna for the soil. I use dot-shaped strokes of heavy Hooker's green to quickly develop the darker areas of foliage in the background. I continue using this green to develop the grassy areas. Then I mix Hooker's green with yellow ochre to add leaves one at a time to the background trees and the tree in the paddock. I also outline the branches of this little tree with light strokes of raw umber. I use light washes of lamp black to solidify the color of the fence.

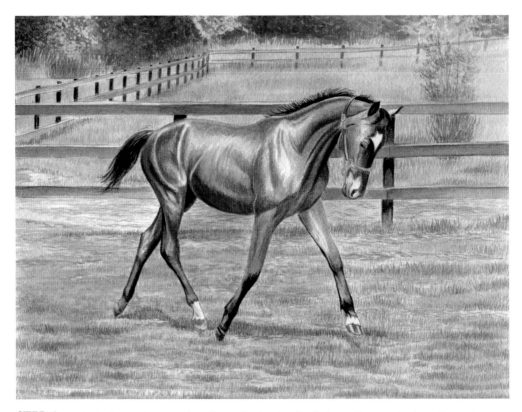

STEP 4 I spend a lot of time in this step on the small vertical brushstrokes of Hooker's green that create the clumps of grass. It's a tedious process, so I take frequent breaks to walk around and rest my eyes. Notice that the grass in the back paddock is longer. To keep things interesting, I alternate between working on the horse and foliage. I develop more of Showdin's musculature by darkening the edges of his neck and rump with strokes of burnt umber. I continue darkening the trees in the background with dot-shaped strokes of Hooker's green. I use yellow ochre for the lighter foliage as well as a 50-50 mix of Hooker's green and yellow ochre. I also add dot-shaped strokes to the little tree in the paddock. The extra dots add definition and visually divide areas of branches. I tone down some of the background green with a 50-50 mix of Hooker's green and raw umber. I also develop the halter by adding raw umber to the edges, and I put the dark mane back in with individual brushstrokes of lamp black. I add diluted Payne's gray to the muzzle and outline the nostril in lamp black. I also darken the lines of the fence in diluted lamp black to make them easier to see amid all of the green.

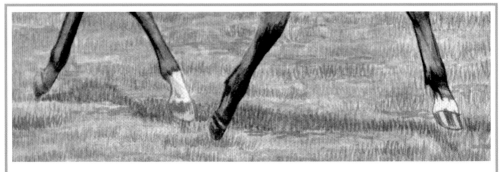

DETAIL 1 Each of Showdin's hooves is different. On the legs with white markings, he has light-colored hooves. I build up layers of diluted yellow ochre for these, and I add details and stripes in heavily diluted Payne's gray. The two legs without white markings have darker hooves. I paint these in layers of lamp black and use fewer layers to distinguish the coronet bands, which separate the legs and hooves. Notice the dark shadows on the right tips of the hooves. For these, I build up layers of lamp black using less and less water for each layer until I'm almost working with a dry brush. The green of the shadow below shouldn't overlap the hooves. This is easy to achieve by carefully taking the green right up to but not overlapping the hooves.

STEP 5 Now it's time to remove the masking fluid with a cotton swab and kneaded eraser. I've painted over it, but it's easy to detect due to its raised surface. The white of the paper shows through once the masking fluid is gone, and I lay down light washes of Hooker's green to tone down the brightness. I add small strokes of diluted raw umber to the soil for depth. A few more strokes of Hooker's green with a nearly dry brush balance the whole image and tie it together. I add more long heavy strokes of lamp black to the fence. I continue building darker layers of burnt sienna in Showdin's coat, rib area, shoulder, and back hock joint. I soften his mane by slightly smudging the strokes with a damp cotton swab. I darken the shadows on his neck and legs with raw umber and reduce the highlights on his hocks, knee, back, and rib area with light washes of burnt sienna.

DETAIL 2 The finishing touches for Showdin's head and neck include strokes of raw umber for the halter and lower eyelid. I add one more layer of lamp black to define his nostril and a small stroke of Payne's gray to depict his lip. For his ears, I carefully outline the edges in lamp black. There is a lighter area inside the ear, which I create with a few delicate strokes of heavily diluted burnt sienna. I also add intense shadows on the right edges of his face, neck, and chest. I use raw umber for these shadows with strokes radiating inward from the edge so they taper naturally and blend into the coat.

Tip!

Raw umber is great for lowering the intensity of green. Care must be taken not to add too much or your color will get muddy and dull.

NEAR THE IN GATE

This painting represents one of my favorite equine sports, hunter. The sport comes from the tradition of foxhunting, and the fashion and overall appearance of the horse and rider have not changed much in hundreds of years. I saw this rider and her warmblood horse at the Ottawa Capital Classic horse show at the Nepean National Equestrian Park, where the grounds are truly spectacular. The rider was waiting at the "in gate" to start her competition. Hunter is a disciplined sport with judging based on the appearance, form, and abilities of the horse and rider.

PALETTE

alizarin crimson, burnt sienna, burnt umber, cadmium yellow, cerulean blue, Hooker's green, lamp black, Payne's gray, raw sienna, raw umber, titanium white, ultramarine blue, viridian green, and yellow ochre

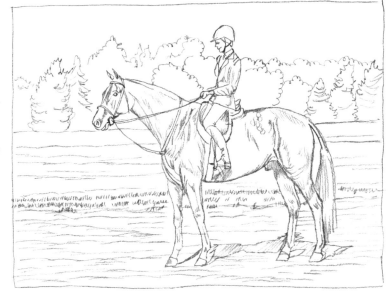

STEP 1 In this sketch, each tree is a different abstract shape, which will help me differentiate them in the painting. I outline the horse's shadow and add lines to separate the major areas of color, such as on the ground and the horse.

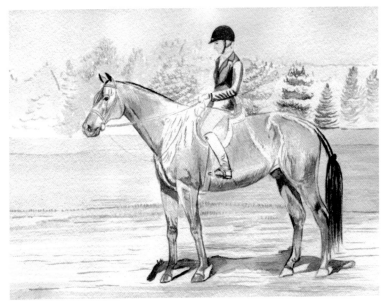

STEP 2 I develop light shades of yellow ochre and burnt sienna for the horse's coat with burnt sienna and burnt umber on the barrel. Light washes of raw sienna color the tack. I lightly add the horse's shadow in Payne's gray. I mix yellow ochre with Hooker's green for the grass. Dots of Hooker's green suggest individual blades. I lightly add varying intensities of burnt sienna for the dirt and cerulean blue for the sky. I use Hooker's green for the pine trees and viridian green and raw umber for the spruce. Sharp strokes radiate upwards or outwards from the center of the trees.

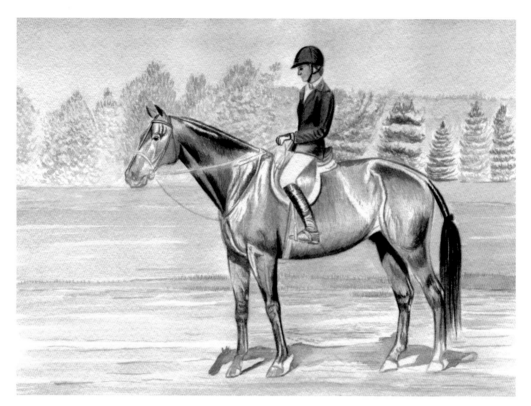

STEP 3 I start to darken the black points on the horse's legs and braided tail with about three layers of lamp black. The untouched highlights suggest shine. I layer over the horse's coat with raw sienna, and I'm careful to leave the highlights untouched. The trees in the background start to take shape with varying intensities of Hooker's green for the deciduous. I add raw umber and lamp black to the green of the pine and spruce. I lay down cadmium yellow washes in the two hardwood trees behind the rider. I darken the grass with Hooker's green and cadmium yellow. I build more layers of the colors already established for the sky and dirt. I paint the muscles on the rump of the horse with small strokes radiating outward in burnt sienna. I darken the shadows on the background legs with raw umber. For the rider's pants, I use a very light wash of yellow ochre toned down with raw umber. I develop her boot with heavier layers of lamp black on the edges and lighter layers in the middle. I darken areas of the saddle with burnt umber and outline its flap with a single stroke of raw umber, a color I also use for the shadow at the edge of the white saddle pad.

DETAIL 1 The rider is wearing a tailored jacket, which I first rough in with light washes of Payne's gray with ultramarine blue added. I build darker, heavier strokes to show the creases in the sleeve. Her face gets a light wash of raw sienna, and a dot of Payne's gray shapes her eye. I use lamp black for her helmet and strap.

DETAIL 2 I further develop the rider's face, which I consider the hardest part of any painting, with very light washes of alizarin crimson on top of the raw sienna from Detail 1. I outline her helmet strap in lamp black and use raw umber for her hair. I remove some of the black from the helmet with a damp cotton swab because I added too much in Detail 1. I continue developing her jacket in varying intensities of lamp black, which also colors her glove.

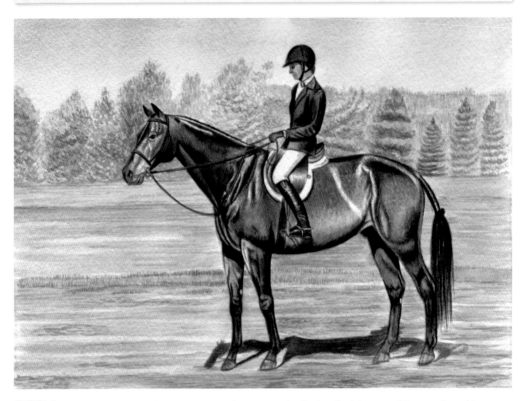

STEP 4 I continue darkening the colors in ever increasing layers. Raw umber develops the darker areas of the arena dirt, and I use slightly rectangular-shaped strokes to suggest bits of gravel. I develop the horse's face by building layers of burnt umber and cadmium yellow while maintaining the white highlights. I give the background trees individual attention by building on already established colors. To add realism to the trees, I add titanium white to my mix of Hooker's green, ultramarine blue, and raw umber. The branches have dark areas underneath, which I build in strokes of the corresponding color with heavier paint to water ratios. For the intense shadow on the horse's rump, I mix alizarin crimson and ultramarine blue and add heavy strokes in two layers. Alizarin crimson also darkens the saddle. I heavily apply Payne's gray to the shadows in the rider's jacket and add more washes of lamp black to her glove and boot. The shadows on the horse's body get heavier layers of raw umber. Heavy strokes of alizarin crimson create a deeper red in the shoulder area.

DETAIL 3 As the shadow on the ground builds in layers of diluted Payne's gray, I'm careful to let some of the brown show through. This ensures the shadow is not one dark blob. In the final step, I use a touch of alizarin crimson to complete the shadow and give it a deep purple color. Notice the defining strokes of lamp black that distinguish the coronet band, where the hair begins growing above the hooves. I also darken the legs and tendons with more lamp black.

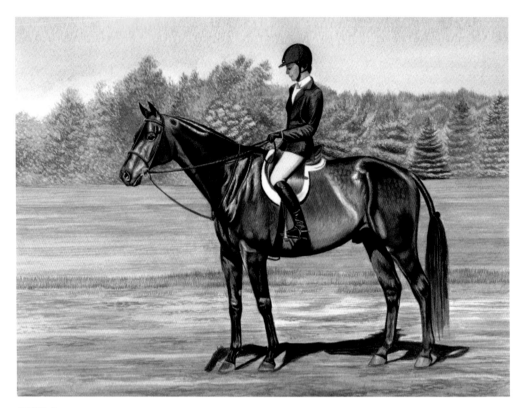

STEP 5 I separately add many more layers of yellow ochre, burnt sienna, burnt umber, and then raw umber to the body of the horse. I let each layer dry in between. Notice the yellow ochre on the horse's barrel is left untouched to show the lighter hues. More layers of burnt umber and raw umber darken the ground, and I add dots of individual pebbles. I add one final layer of cerulean blue mixed with titanium white to flatten the sky. I finish the tail with lamp black and the tack with alizarin crimson. Then I add a dark stroke of raw umber to the bottom of each strap of the tack. I layer alizarin crimson over the saddle, as reddish tack was popular at the time of this show. I give more detail to the shoulder area of the horse by darkening the outlines of the muscles with raw umber and alizarin crimson. I leave the highlight areas pure white. For the grass, I add more small brushstrokes and then a wash of cadmium yellow. I outline the rider's face one more time with Payne's gray. Her jacket gets an overall wash of ultramarine blue because it had gotten too gray. I finish her glove and boot with lamp black on a nearly dry brush using strokes that radiate inward toward the highlights.

DETAIL 4 I add dapples on the coat by carefully painting in small irregular circles in a checkerboard-like pattern in alizarin crimson mixed with ultramarine blue. Dapples are a nice finishing touch but are not seen on all horses, so careful observation is a must.

DETAIL 5 I finish the trees with dot-shaped strokes of Hooker's green. For the trees farthest away, I combine Hooker's green and ultramarine blue for a final wash. This flattens these distant trees and gives them a bit of depth.

THREE PONIES

This is a challenging painting. These three ponies need individual definition and a sense of separation, but, at the same time, togetherness. Before they came together in this painting, I photographed them each separately years ago. This has become one of my best-selling images, and I still find humor and charm in these three ponies.

PALETTE
burnt sienna, cadmium yellow, cerulean blue,
Hooker's green, lamp black, magenta,
Payne's gray, raw umber, titanium white,
ultramarine blue, and yellow ochre

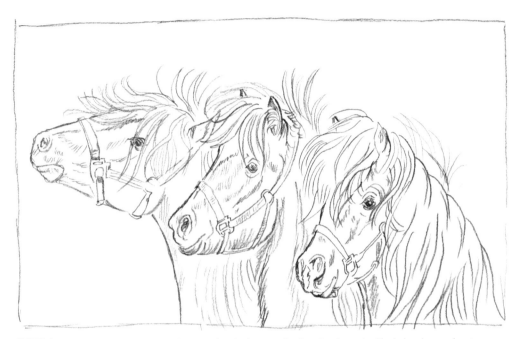

STEP 1 In this sketch, I use slightly darker lines to outline the three pony heads so that the tangle of forelock and manes do not overwhelm the entire painting. I can easily see where the manes and forelocks overlap each other.

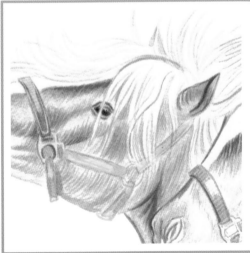

DETAIL 1 I am right-handed, so I work on this project from left to right to avoid smudging the paper. This means the pony on the left gets more attention in the beginning stages. I build more layers of burnt sienna and yellow ochre in his face than in the others. I continue building more layers of burnt sienna for the darker areas in a 50-50 ratio of paint to water. I use tiny strokes of burnt sienna on the far side of his white facial marking to distinguish it from the background. I want his ear to show up in the tangle of his mane, so I outline the tip slightly with dry burnt umber. The cheekbone also gets a bit of dimension in this dark color. I mix titanium white and yellow ochre for his slightly blond mane and forelock. His halter is a mix of cadmium yellow and Hooker's green. I slowly add details to the halter fittings and buckles in yellow ochre with raw umber shadows underneath.

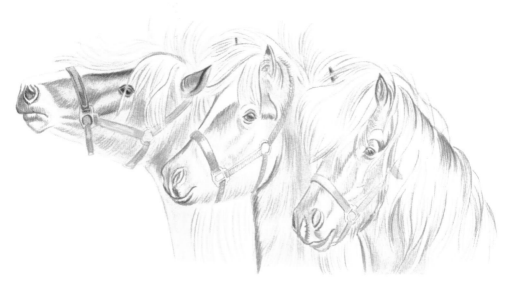

STEP 2 I block in areas of rough color using a mix of burnt sienna and yellow ochre. For the halters, I mix magenta and ultramarine blue (middle) and ultramarine and cerulean blues (right). Each halter has areas of highlights that I leave white. I'm using longer brushstrokes to define the long hair of the manes and the neck of the middle pony. I focus on the eyes with heavy dots of burnt sienna and a dot of titanium white for the highlight. I also add detail in burnt sienna around the eye and eyebrow area. The muzzles at this stage have preliminary strokes in heavily diluted lamp black. I carefully add small tight strokes to suggest nostrils and wrinkles around the lips, and I leave the paper blank for their facial markings.

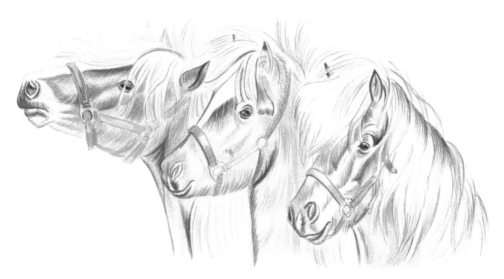

STEP 3 The three ponies are slightly different shades of red, and I build up layers for each using burnt sienna, raw umber, yellow ochre, and cadmium yellow in different combinations. I use a #3 brush with hardly any bristles left for the long, thin brushstrokes of the manes and forelocks. The middle pony's mane reflects shades of burnt sienna. The pony on the right has an almost white mane, so I outline it in strokes of raw umber. I darken the individual halter colors, and I'm careful to leave the white highlights. Notice the hair on the bottoms of their chins. I add these in one at a time with dry brushstrokes in colors that match their coats. I use longer brushstrokes for the pony in the middle as the hair on his neck is longer than the others. I add strokes of Payne's gray to the eye areas and darken the pupils substantially with heavy dots of burnt sienna. I add one dark lamp black stroke to the center of each pupil. The pony on the right has a shadow of raw umber above his eye.

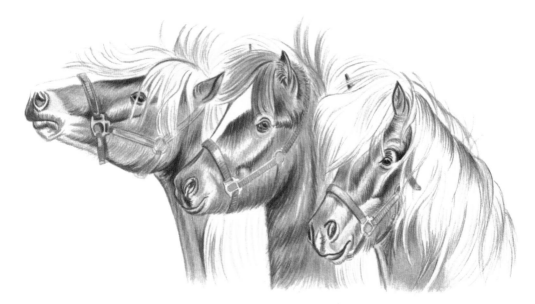

STEP 4 The ponies are nearing completion as I continue to build additional strokes of the established colors slowly and in layers. I leave white areas on the nylon halters and add in vertical strokes to depict the webbing of the nylon. I pay particular attention to the ponies' eyes. I give them individual eyelashes using burnt sienna for the middle pony and very light strokes of titanium white for the other two. I also outline their eyelids in Payne's gray and lamp black. Their muzzles and nostrils add to their charming expressions. I darken the muzzle areas with shades of Payne's gray and diluted lamp black. The hair here is very soft, fine, and short. I continue developing their manes with a few hairs crossing over lower layers to add realism. I add shadows on the insides of the metal rings of the halters using raw umber to create depth.

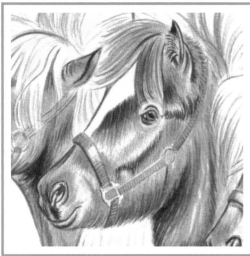

DETAIL 2 Don't let the middle pony get lost between the other two. I separate him from his buddies by leaving his muzzle light. I use small strokes of Payne's gray to suggest the wrinkles, and I overlap these strokes with the yellow ochre of the muzzle. Small but fairly heavy strokes of titanium white define the outside edge of his muzzle and nostril. A dark raw umber shadow runs down the length of his face on the left to distinguish him from the far left pony. Another deep shadow in raw umber under his chin and along his neck gives him more distinction. I add a few dark strokes of raw umber on top of the purple halter. I use tapering strokes in a downward motion from the jaw to define the hair on his chin with raw umber. Then I add a little burnt sienna in strokes angling down to further define this area.

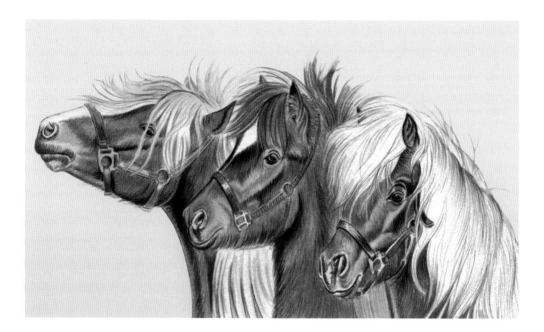

STEP 5 In the final stages, I darken the layers and add more brushstrokes to define the long hairy coats. I complete the halters, leaving white areas for highlights and adding vertical strokes to depict the nylon webbing. I finish the muzzles by bringing the face colors in closer to the lips. Then, I finish shaping the facial bones with darkening shades of burnt umber and then raw umber. The cheekbone strokes are small and thin. I use a #0 brush and carefully add one stroke at a time so the shadows don't get too overpowering. It is important during this final step to make sure the ponies are clearly differentiated. To accomplish this, I add deep, dark shadows of raw umber to the edges of their necks. This also helps to unify the image. Finally, I add a gradient of yellow ochre and burnt sienna in a very light wash for a simple background that doesn't compete with the detail in the ponies' faces.

DETAIL 3 Creating a gradient requires practice. If you are unfamiliar with the technique, I recommend practicing first on a separate piece of paper. I use a large round squirrel-hair brush and paint about six layers of the lightest shade. In this case, I use yellow ochre and burnt sienna (about a 75-25 mix) heavily diluted with water. I lay down flat washes and let each dry before adding the next. Then I increase the amount of burnt sienna to about 75 percent of the color mix. I start applying this mixture about halfway down. I add lots of water to the top edge of the wash so it blends and flows into the established layer. When these three or four washes dry, I apply one final wash. You may prefer to add the gradient before painting the ponies or in Photoshop.

THE STRAGGLERS

This serene ranch setting takes this modern cowboy out of the rodeo and onto a working farm. He's using a typical western or stock saddle, and he carries one of the tools of the trade, a lariat for lassoing cattle. This style of riding evolved from working ranches and cattle drives, and weekend rodeos keep the tradition alive and well.

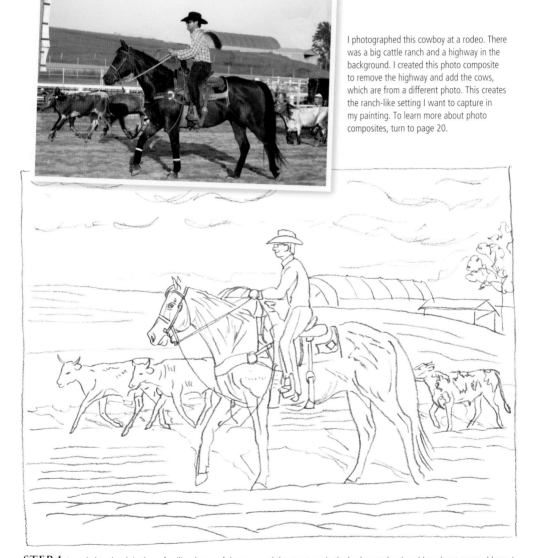

I photographed this cowboy at a rodeo. There was a big cattle ranch and a highway in the background. I created this photo composite to remove the highway and add the cows, which are from a different photo. This creates the ranch-like setting I want to capture in my painting. To learn more about photo composites, turn to page 20.

STEP 1 I needed to sketch in the unfamiliar shapes of the cows and the structures in the background so I could work out any problems. I moved the cows around to make a more pleasing arrangement.

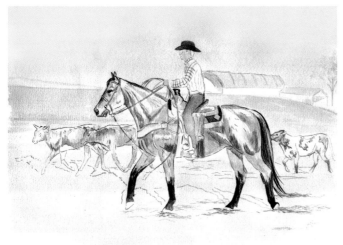

STEP 2 I begin this painting, as I do many others, with washes of burnt sienna for both the horse and cows. I use diluted lamp black for the legs of the horse as well as the mane, tail, cowboy hat, saddle horn, and detail of the saddle blanket. I lay down light washes of cerulean blue in the sky. I suggest the outline of the shadows on the ground in raw umber. I lightly outline the cowboy in raw umber as well, and I add a wash of ultramarine blue for his jeans. I begin developing the lines of alizarin crimson strokes that will create his plaid shirt. I use burnt sienna for his saddle, bridle, and lariat. I lightly outline the buildings in Payne's gray and lightly paint the tree using raw umber to outline the branches. I add a few leaves with very light dot-shaped strokes of Hooker's green. A light wash of bright green establishes the grass.

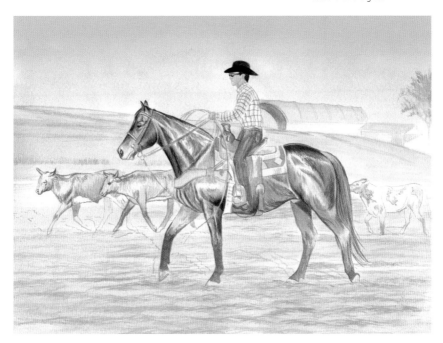

STEP 3 I darken the layers of burnt sienna and lamp black on the horse, whose bay color has prominent red tones. Then I add raw sienna for the darker coat areas. I develop the cows in burnt sienna washes and the buildings in shades of Payne's gray with diluted lamp black shadows. I use long, horizontal strokes of Hooker's green to suggest the grass, define the slopes, and add depth to the hills. For the sand ring, I layer in burnt sienna and burnt umber in light strokes to suggest the uneven dirt. I use flat layers of raw sienna for the saddle, bridle, and breastplate.

DETAIL 1 I rough in the face of the cowboy with small strokes and layers of diluted cadmium red and yellow ochre. I use the colors separately with a #1 brush to work on the small details. His sunglasses give him a modern look, and I use lamp black with a highlight left in the closest lens.

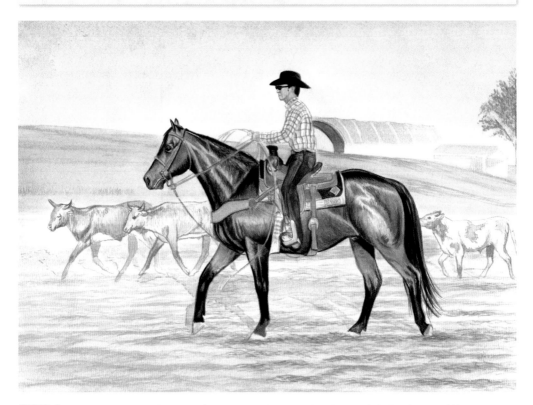

STEP 4 Dark shadows painted in three layers of burnt umber on the back, neck, and chest unify the horse's coat. I add long narrow strokes of heavy lamp black to all four legs. I use the same heavy color for the black tape on the saddle horn, and I darken the saddle with raw sienna. I complete the cowboy's face with light lines of Payne's gray and add almost dry strokes of ultramarine blue mixed with Payne's gray to his jeans. I especially darken the top of the far leg that's visible. I suggest morning sun with light shadows of heavily diluted ultramarine blue on the ground behind the horse and cows and under the cowboy's arm. I gradually add layers of burnt sienna to depict the raised sand. For the grass I now combine Hooker's green and cadmium yellow. I add small vertical strokes of viridian green to suggest the longer grass. The lone tree darkens with Hooker's green for the leaves and raw umber for the trunk. A bit of cadmium yellow lightens the tree's value.

DETAIL 2 Details slowly build in layers to define the horse's face and tack. I use a heavy mix of raw umber and lamp black (50-50 ratio) on his jaw line and the top edge of his face. I darken his muzzle with Payne's gray and outline his nostril in almost dry strokes of lamp black. I add detail to the eye area with small strokes of Payne's gray under the eye, heavier strokes of raw umber above, and dots of almost pure lamp black in the pupil. For the bridle, I outline one small dark stroke of raw sienna on the crownpiece (over the forehead), the throatlatch (under the jowl), and the tie down that goes from the noseband down to the cinch. I also add one dark stroke of raw umber on the bottom edge of the headstall, the piece that stretches from the bit to behind the ears, to act as a shadow.

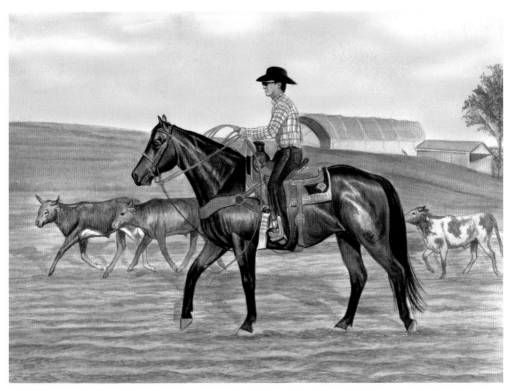

STEP 5 I darken and outline the buildings with Payne's gray and then raw umber. Both colors are well diluted. Horizontal stokes of Hooker's green add variation in the grass. I add marks and color to the cows with a burnt sienna and yellow ochre combination. I lightly go over the existing lines of the bridle and rope with raw sienna. I finish the cowboy's clothing by adding Payne's gray for the contours of his jeans and cadmium red and ultramarine blue for the plaid shirt. I press hard with my brush for three more flat washes of cerulean blue in the sky. I darken the shadows on the ground with Payne's gray. Washes of raw sienna intensify the red of the horse. The tree gets about six more layers of Hooker's green plus a cadmium yellow wash. A hedge develops behind the tree in dot-shaped strokes of Hooker's green. A lamp black shadow finishes the small shed, and I add a yellow ochre wash to both buildings.

DETAIL 3 I layer burnt sienna and raw sienna to depict this double skirted saddle. I outline the edges with very light raw umber and develop a deeper red for the darker areas with burnt umber. For the off-white sheepskin of the saddle pad, I use light strokes of raw umber. The finishing detail is a shadow of raw umber along the bottom and sides of the saddle pad.

DETAIL 4 I want to add clouds at this stage, but I've already laid down several blue washes in the sky. Since I can't cover these washes with white watercolor, I use an airbrush and compressor with thick titanium white gouache paint. This easily allows me to cover the cerulean blue in the sky. I could also add them in acrylic or use masking fluid in the beginning to preserve the white of the paper for the clouds.

CLOSING THOUGHTS

As an artist, you must become a student of everything equine. Observe, learn, draw, and photograph your subjects at rest and in action. Also, realize that painting takes many years to master and patience is a must. Take small meaningful steps toward capturing the splendor of horses and ponies. Breaking down their complicated anatomy into simple underlying shapes will help you become an increasingly competent artist. Remember to work slowly using a light-to-dark layering technique. As your skill and comfort levels increase, gradually increase the difficulty of your projects as well.

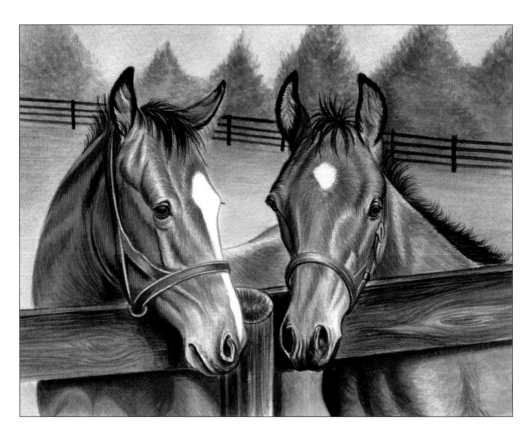